Goth-Icky

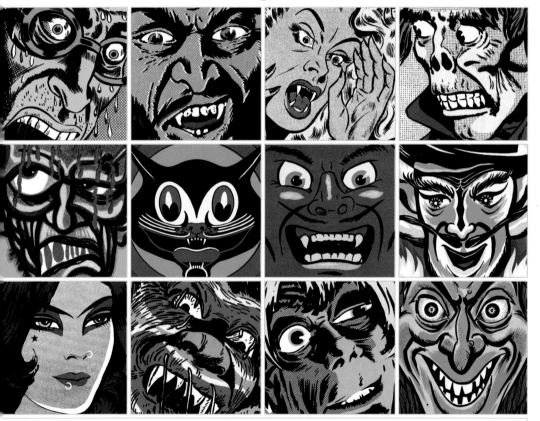

A Macabre Menagerie of Morbid Monstrosities
Charles S. Anderson Design Company
Text by Michael J. Nelson

Harry N. Abrams, Inc., Publishers

www.popink.com
www.csadesign.com
www.csaimages.com

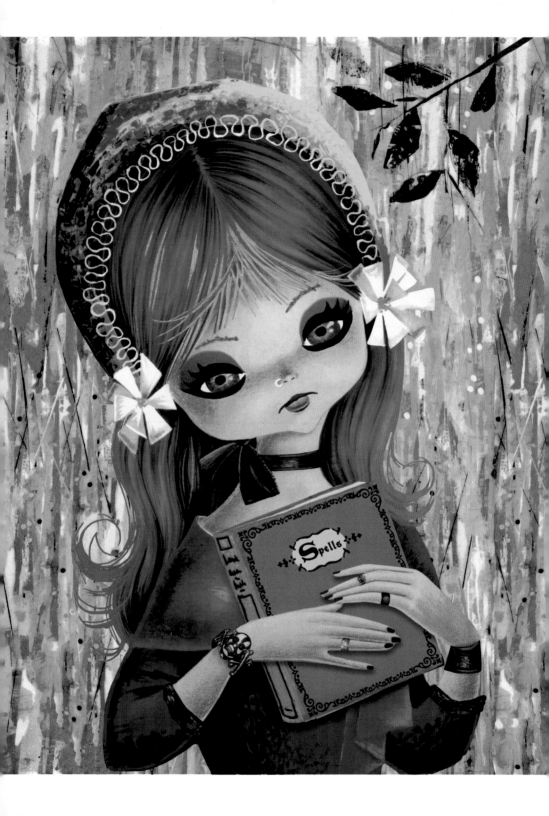

Pop ink

Goth-Icky

A Macabre Menagerie of Morbid Monstrosities

Ask any Goth what it means to be Goth and you are likely to get a myriad of answers. Some will say it's all about the music; others, the fashion. A good number will say it's about the literature, or the arts. Ask enough of them, though, and you're likely to find that a small but significant number will simply shout, "Piss off, fascist!" and toss a half-finished Shamrock Shake at you, staining your favorite pants.

To be a Goth is to run counter to the prevailing cultural winds. If society mandates that it's "proper" to appear in public looking like you're alive, a Goth says phooey on that, and goes anywhere he likes looking quite dead, not to mention as if his body's been drained of blood. No gigantic leather wrist cuffs studded with razor sharp spikes, you say? Bah, says the Goth, and dons several of them, along with a large carabiner clip punched through his bottom lip just for good measure. Think people generally

shouldn't smell like canned tamales that have been aged in a bowling shoe for ten months? Well, pardon me, sir, but you don't know what the hell you're talking about! That is why they created patchouli oil–for smelly Goths to splash it on by the gallon.

And what of their music? Offer your average person songs involving death, mutilation, and vampirism, and he is most likely to say, "Thank you, no. Would you happen to have any peppy tunes about girls?" But Goths seem to eschew the ordinary, preferring that their bands dress up in funereal costumes and sing about corpses instead.

Though the rise of Goth culture is relatively recent, its origins stretch far back into history. They can be traced to the 1400s, when the Transylvanian king Vlad the Impaler woke up one day and said, "Man, I hate my name. All the other rulers make fun of it. I know! I'll impale 60,000 peasants, then it will actually make sense!"And so he did.

Vlad also enjoyed skinning his enemies alive, drinking their blood, and gouging out their eyes– or else openly mutilating them–all for his own amusement! And from this behavior alone, a legend grew that he was somehow a "monster." (What ruler doesn't mutilate and torture a couple tens of thousands of subjects every once and a while? But somehow, history continues to pick on poor Vlad.)

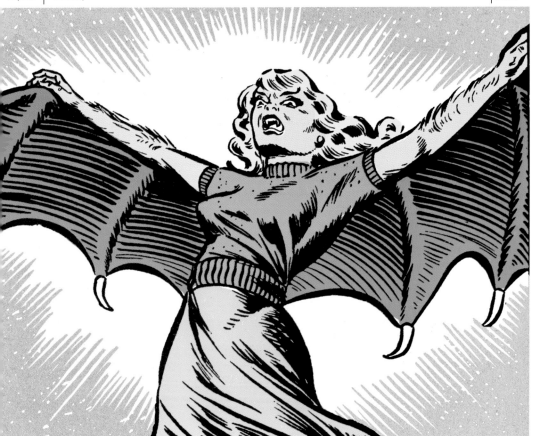

According to the legend of Vlad the Impaler—his golfing buddies teasingly called him "Dracula," which means "dragon" or "devil"—a whole culture of monsters soon blossomed. The monster roster grew to include such classics as witches, ghouls, zombies, werewolves, trial lawyers, and mummies, each competing to be more gruesome than the next. Like a sports team, each began to accumulate its own devoted group of fans. (In such a scenario, the always-struggling ghouls would probably be the Kansas City Wizards soccer team.)

Today, in nearly every community across the globe, there is a vibrant cult of death. Goths are average, everyday citizens. They are your friends, and even your neighbors (provided, of course, that your friends and neighbors happen to be pale, skittish, black-clad creatures who avoid eye contact and don't ever mow their lawns).

Goth-Icky celebrates the Goth. And it goes one step further (at no extra cost to you!), by celebrating the monsters, cadavers, witches, bloodsuckers, zombies, ghosts, and ghouls that bring infinite happiness into the lives of Goths everywhere.

If we have done our jobs well, the images in this book should make you and a great many other people happy, too. If, for instance, you're having a bad day–maybe you reached back into the car to get your French Vanilla MooLatte out of the beverage holder after you'd already begun to shut the door, and the door swung closed on your head, badly lacerating your scalp, and causing you to need thirty-eight stitches and a rigorous program of antibiotics–then your day will most certainly be brightened by the many whimsical images of weeping head wounds and rotting flesh contained within the pages of this book. So break out the black lipstick, and the latest Marilyn Manson tunes, sit down with this book, and enjoy–or despair.

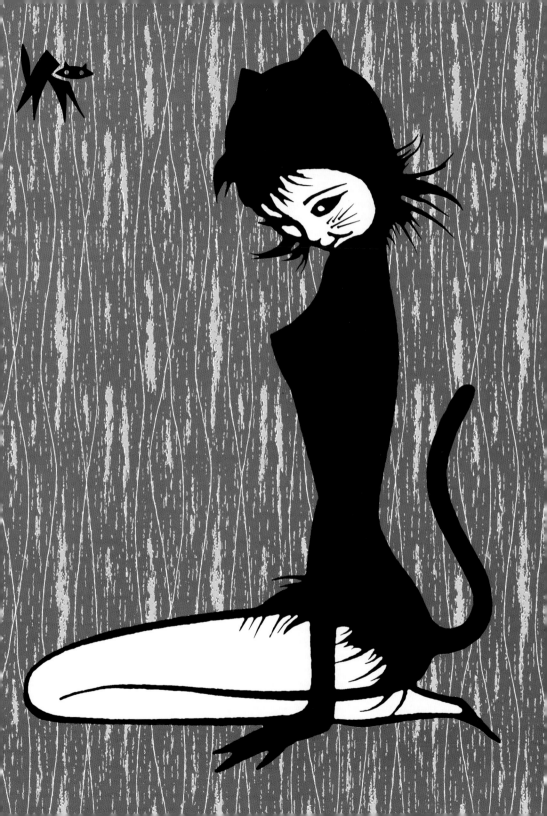

GOTH

Let's face it–if you have a head shaped like a sideways egg, there's very little you can do to hide that fact. But that doesn't mean you can't try to distract people from noticing by dying your hair the jettest of blacks, fanging up, troweling on the eye makeup, and piercing any part of your body that happens to be protruding and is within reach. In fact, there is no one who doesn't look better after having hoops of metal punched into various parts of their flesh. Just be sure to get your piercings at a reputable, accredited piercer. (Avoid "Dirty Doug's Discount Piercings and Taxidermy.")

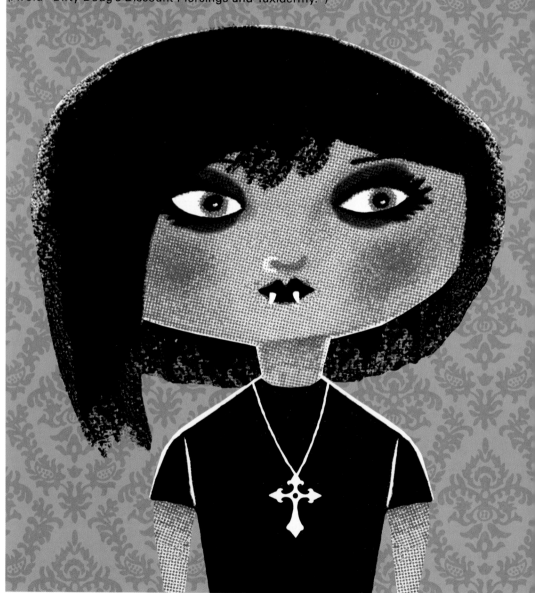

BEFORE: Cute? Sure. BUT CUTE DOESN'T FEED THE BULLDOG, SISTER! Macabre is where it's at, and you're about as macabre as a fuzzy little bunny.

AFTER: There. A few skulls, some makeup. Don't you feel better knowing that the world now views you as someone who may or may not do the bidding of Satan?

GOTH

Aside from the clothing, hairstyles, piercings, and death imagery, it's important that a Goth display the proper attitude. It's essential, of course, to take care not to display any pep whatsoever. Levity, too, is for squares. Try to convey this terse, simple message: "I'd rather be dead."

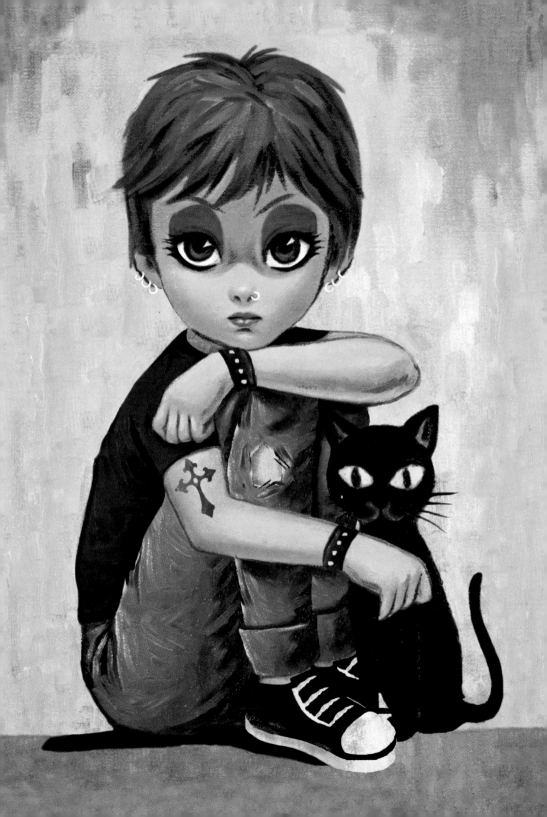

BLACK CAT

Black cats have long been a symbol of superstition, almost as long as they've been a symbol of fetid kitty litter, hair balls and pee-stained couches. Pope Gregory IX condemned them as "diabolical creatures." Cats retaliated by asking their good friend the Devil if there was something he could do to harm the pope. "Not a whole hell of a lot," he replied, with a cackle. In reality, there's nothing much to worry about should a black cat cross your path. That is, unless he's wielding a gun or something.

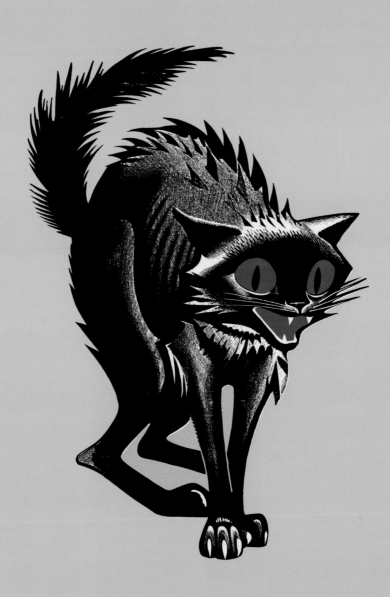

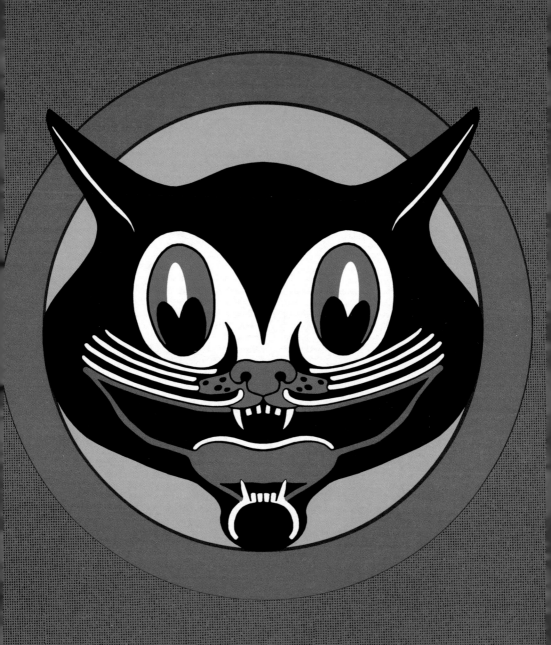

There is an old Welsh superstition that if the pupils of a cat's eyes widen, there will be rain. If that's true, this cat is predicting the storm of the century with flash flooding and gale-force winds. That, or he just had his pupils dialated and accidentally ate a big chunk of wasabi.

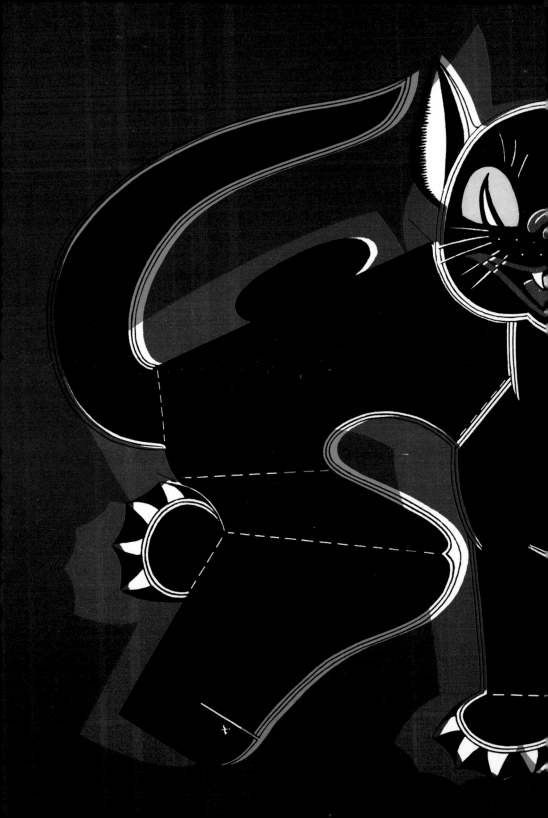

Here's a fun project that anyone can do. Take a live cat, preferably your neighbor's, the one who poops in your sandbox and is always howling, and fold it as shown in the diagram. (Cats are always bragging about how flexible they are, so folding one shouldn't do any permanent damage.) Paint it black if necessary, then either display it in your window or tape it to your front door.

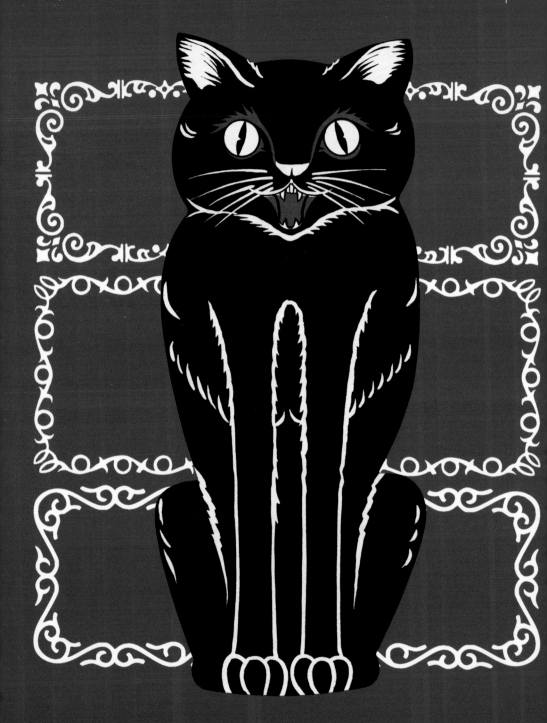

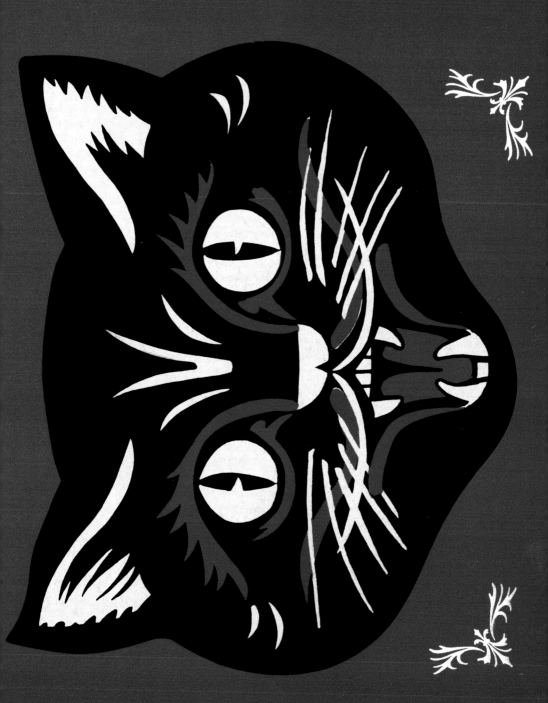

The cat on the opposite page broke both his front legs badly in an unfortunate skiing accident. He was immediately airlifted to a hospital in Denver where his bones were replaced by metal rods.

SKELETONS

The human skeleton is not inherently terrifying–unless it just happens to come alive and stare at you, its hollow, demon-like eyes boring into your very soul! Which it shouldn't, under normal circumstances. If it does contact your local police using their non-emergency number. (Let's face it, a living skeleton can't do squat to harm you. It relies heavily on the muscles and when they're not present, a skeleton is helpless, just a clattering worthless heap of bones.) If your own skeleton begins to behave in an abnormal fashion, contact your nearest orthopedist.

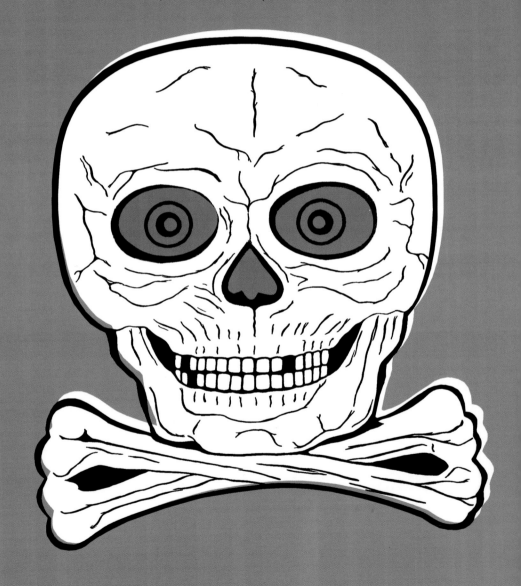

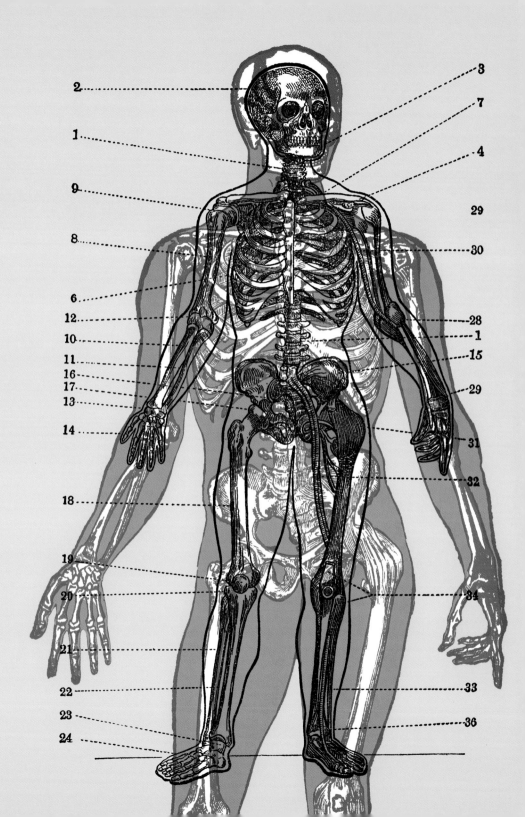

Residents of Zhejiang, China, routinely dig up the bones of women to make "ghost soup," which they believe is a remedy for a wide range of ailments. Campbell's now makes several varieties of condensed ghost soups, including a microwavable "Ghost Soup at Hand."

One of everyone's favorite displays at Chicago's Museum of Science and Industry is the "visible human body," a man and a woman who were frozen solid, cut into medium-thin slices on a band saw–the slices preserved in strong brine for a time–then gently sandwiched between sheets of glass. (What the hell goes in Chicago, anyway?)

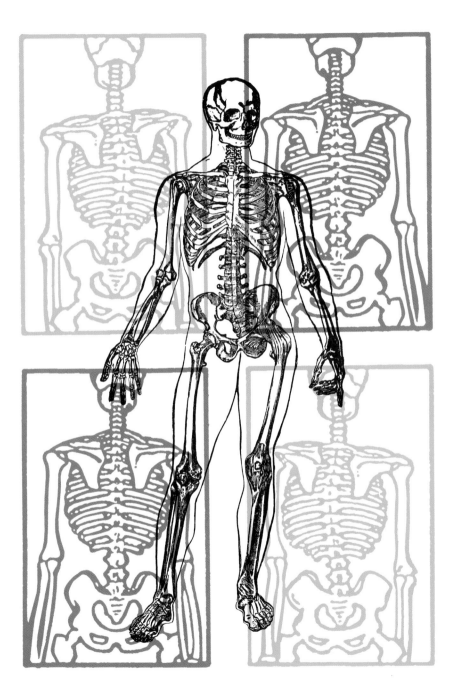

The human body is an architectural wonder, a thing of unsurpassed beauty, a sublime mixture of form and function. Unless you're talking about the male body. That's a lumpy, malformed disgrace.

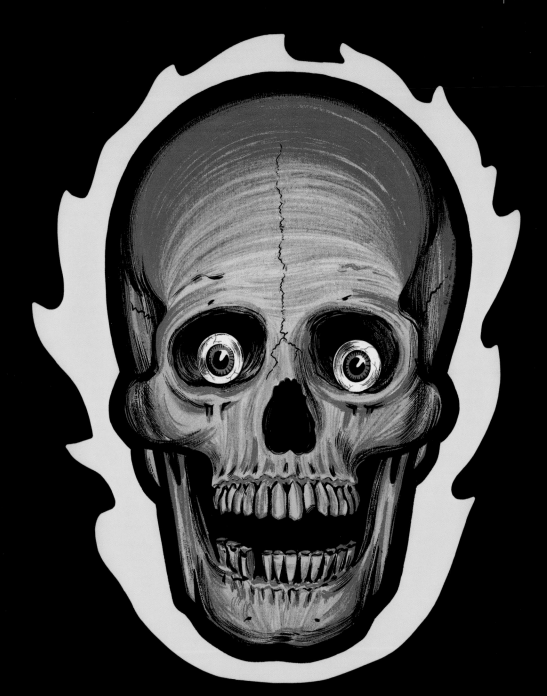

If you want to really irritate a flaming screaming skull, turn him toward something highly unpleasant, like, say, a Rob Schneider movie. He has no eyelids and no way to turn away. It's fun!

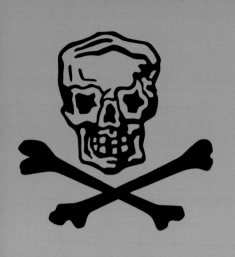
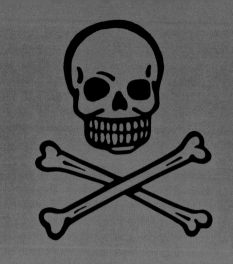
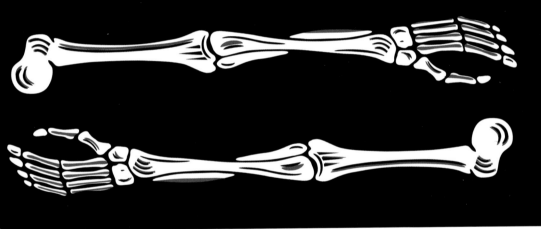

Top and below: Variations on famous "Skull and Crossbones." Above: "Leftover Arms."

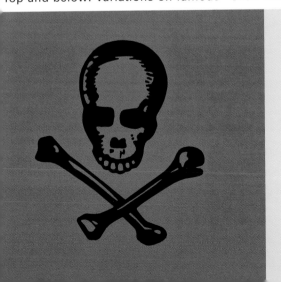
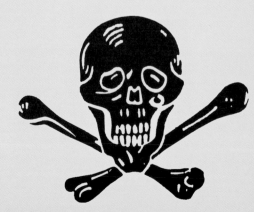

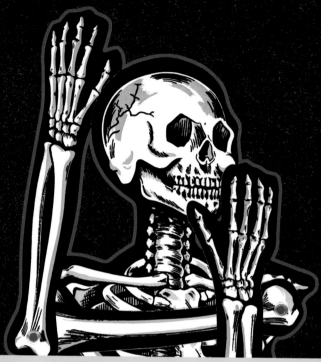

According to the beloved old spiritual, "Your toe bone connected to your foot bone. Your foot bone connected to your ankle bone. Your ankle bone connected to your leg bone. Your leg

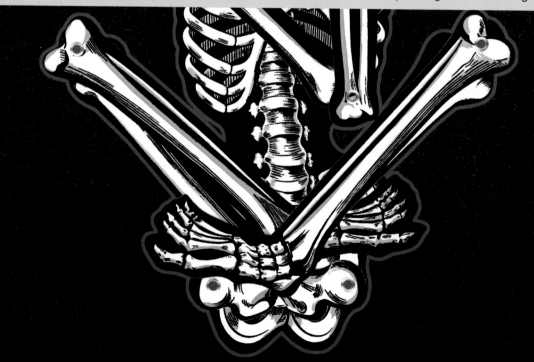

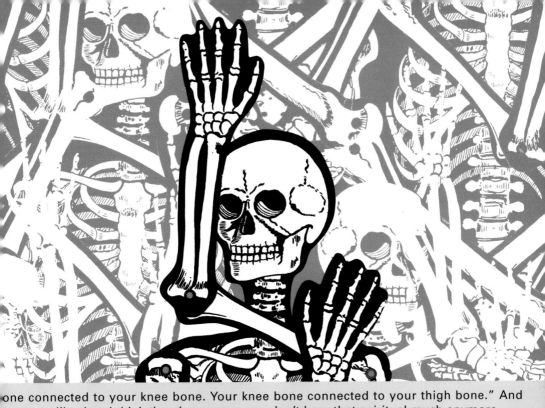

one connected to your knee bone. Your knee bone connected to your thigh bone." And goes on like that. I think there's a reason you don't hear that spiritual much anymore.

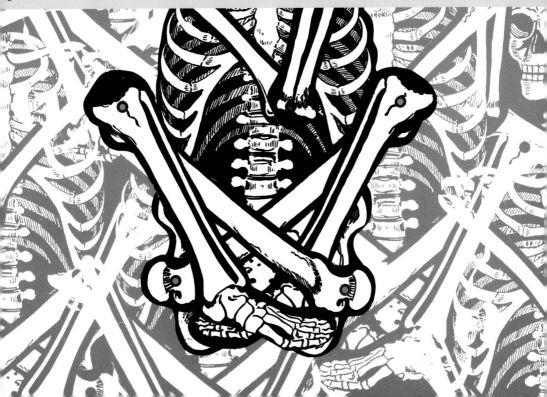

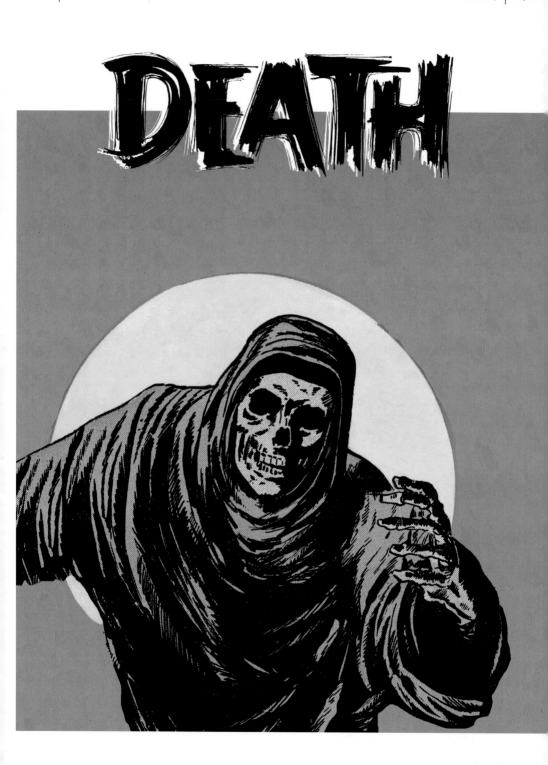

There isn't a person alive who doesn't fear the cold, dank hand of Death. Perhaps that fear wouldn't be quite so widespread were Death to put a little more effort into his appearance. Lose the black hoods, go for a polo shirt in a bright color. With his thin build, he's got to work a little harder to accentuate his few good points. Also, killing people has got to drive his positive numbers down.

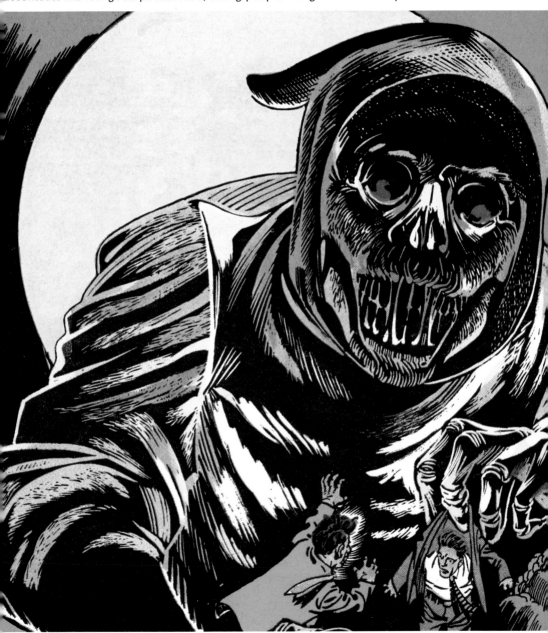

With the support of teenage boys everywhere, scientists developed the first pair of X-Ray glasses n 1951. They succeeded—if only to the extent that they made the wearer look like a giant, comic ɔook-reading, humor-impaired moron. The team that developed them went on to publish the ɔugely significant scientific white paper, "A Treatise on the Efficacy of Rubber Vomit."

Death has always battled a severe gambling problem. Satan has tried to support and care for him, but with Death hitting the craps tables again, Satan knows it's time for some tough love.

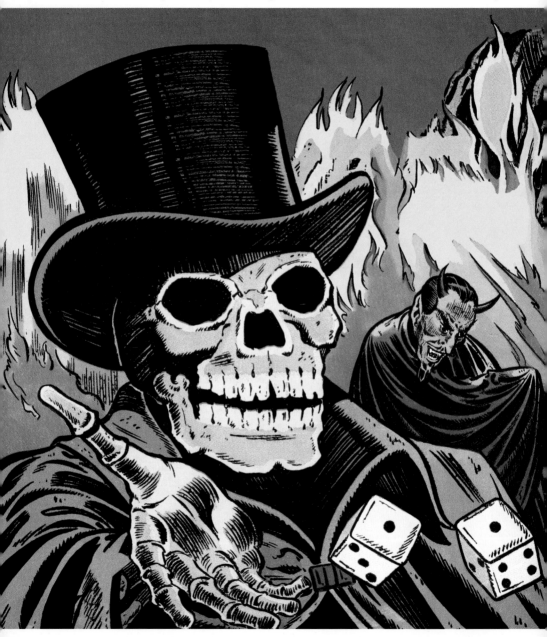

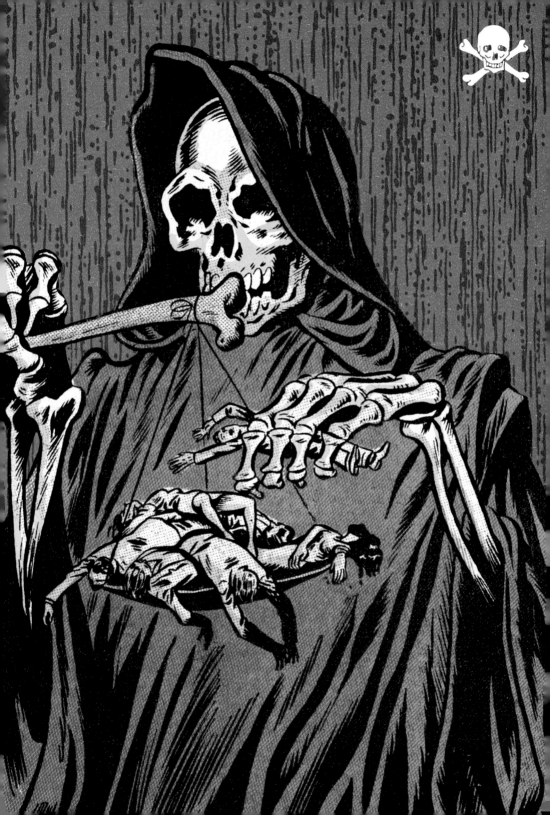

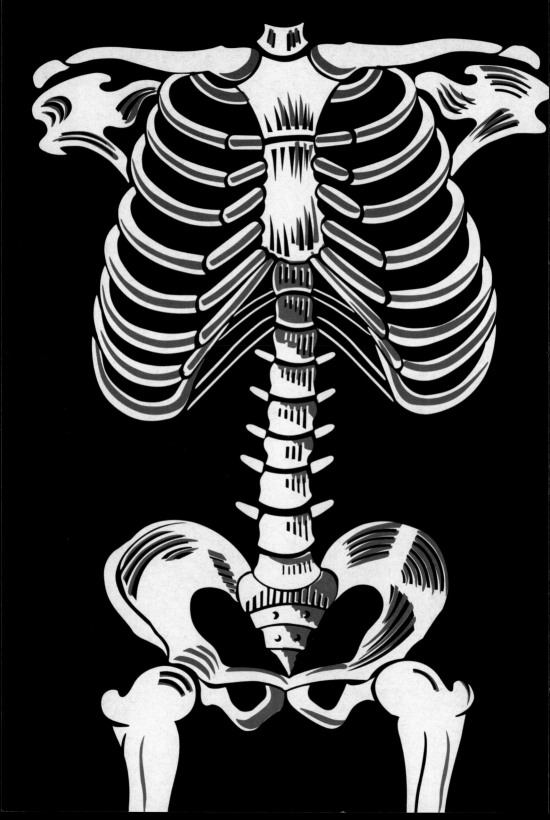

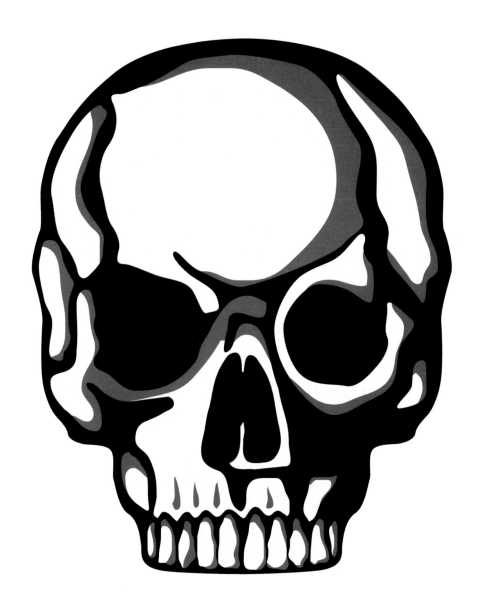

The capacity of the average human skull is nearly one and a half quarts. So if you have an empty human skull around, you can use it to measure broth, soft drinks, or milk for all your favorite recipes.

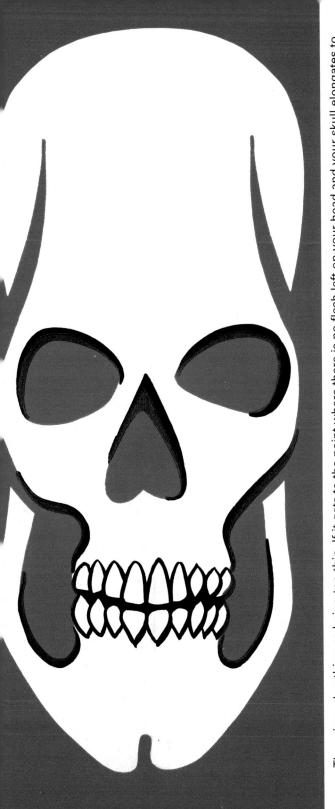

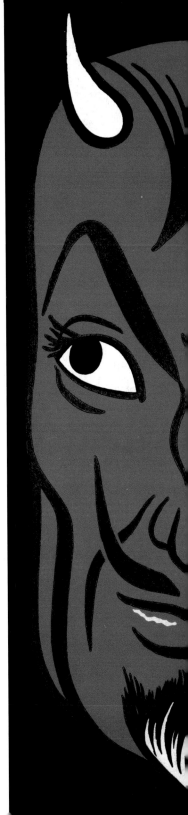

There is such a thing as being too thin. If it gets to the point where there is no flesh left on your head and your skull elongates to an alarming degree, enjoy a nice, fatty meal or two. And if your skull does sprout a pair of horns, try a nice houndstooth hat.

WICKED WITCH

Witches have long been horribly misunderstood. Most people view them as harmless practitioners of an ancient pagan religion. But actually the vast majority of witches are warty, cackling hags in pointed hats who spend most of their time cauldron-side, chanting satanic incantations. That is, when they're not kidnapping little German kids, or riding around on brooms for who knows what kind of devilry. The American Council of Witches just has to do a better job with their PR.

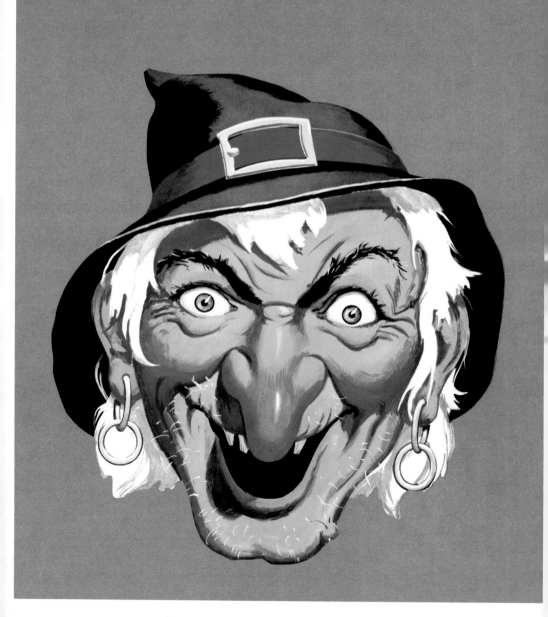

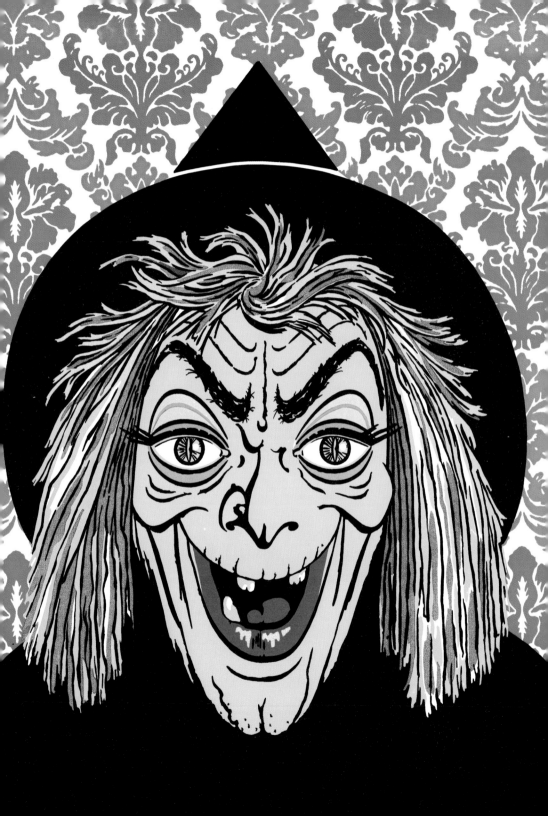

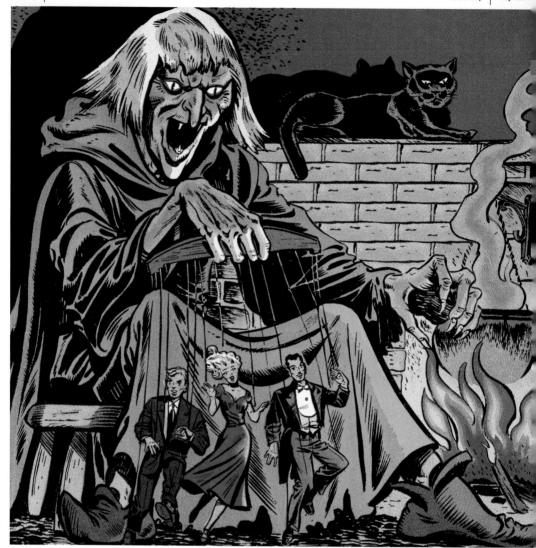

It's nice to see that there's at least one witch out there who has a hobby that doesn't involve casting spells or causing mischief. Of course, marionette puppetry doesn't necessarily contribute to the overall good of man, now that I think about it. In fact, over the course of my life, puppetry of every kind has only brought pain. Burn the witch! Burn her!

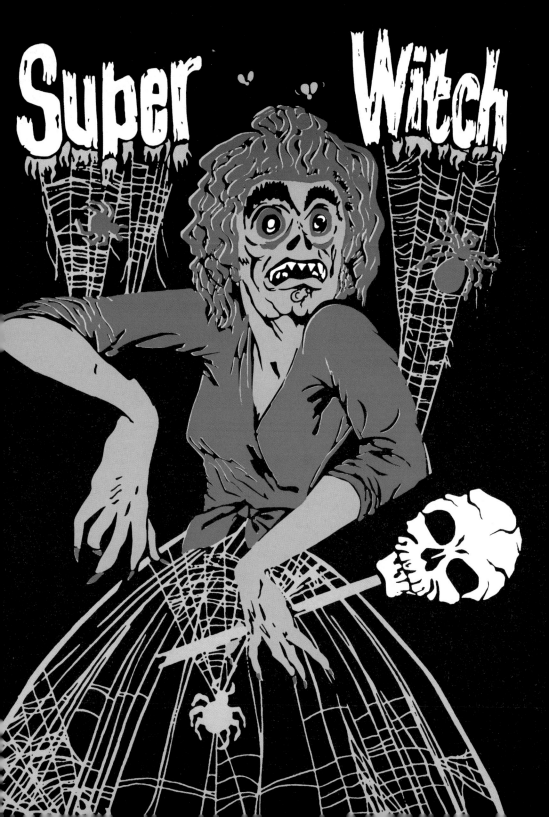

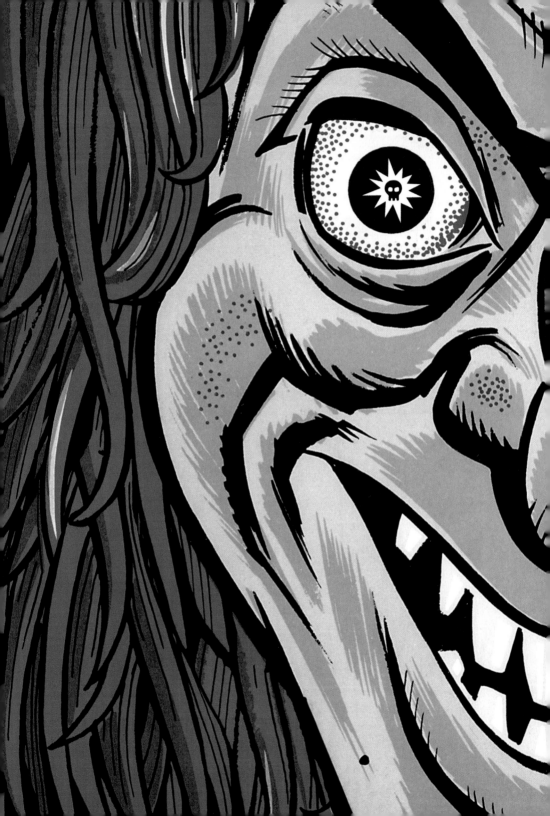

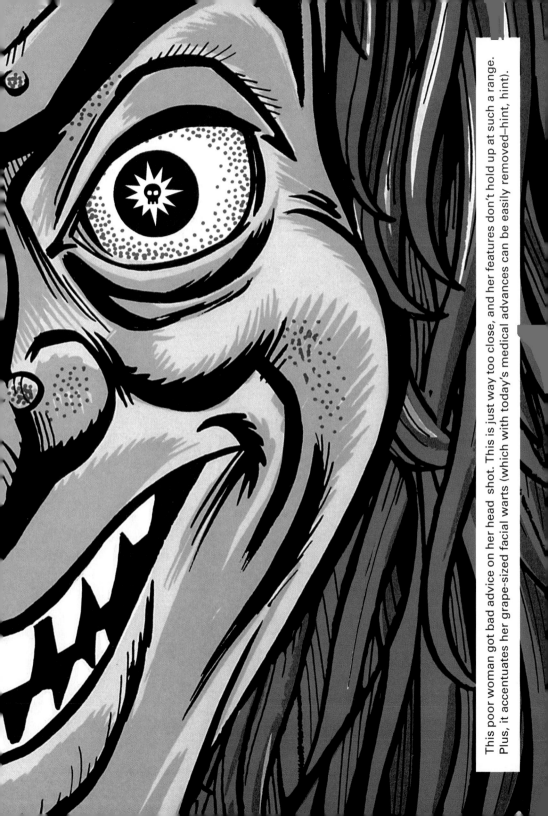

This poor woman got bad advice on her head shot. This is just way too close, and her features don't hold up at such a range. Plus, it accentuates her grape-sized facial warts (which with today's medical advances can be easily removed—hint, hint).

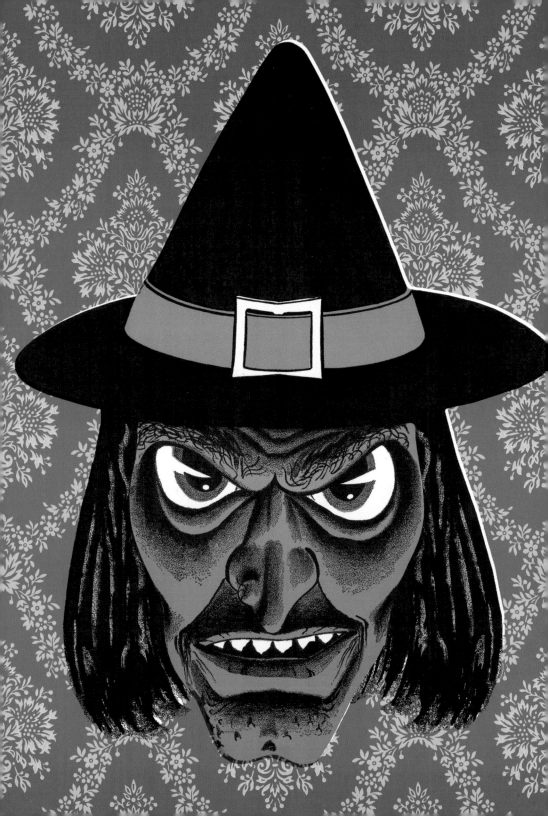

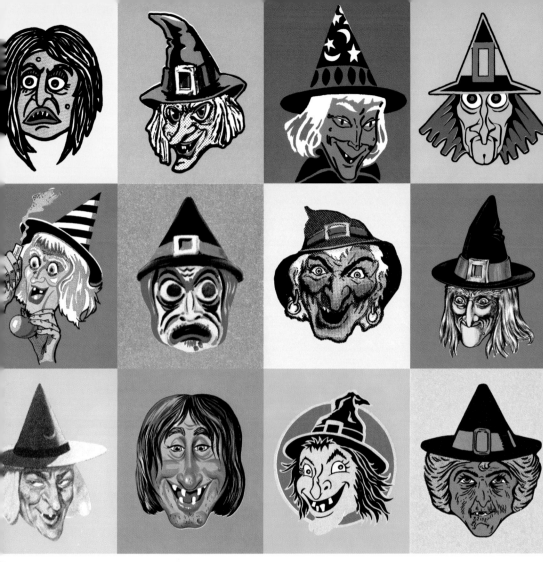

Pictured on these pages are the winners of this year's Miss Witch Pageant, held annually in Tomah, Wisconsin. All things considered, not an attractive bunch, but you have to take into consideration that the scoring is weighted heavily toward personality and the talent contest. The square-headed young lady, below, apparently did a drop-dead song-and-dance version of "I Cain't Say No."

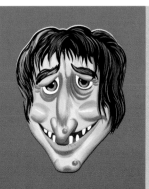
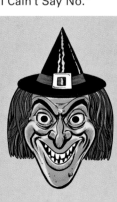

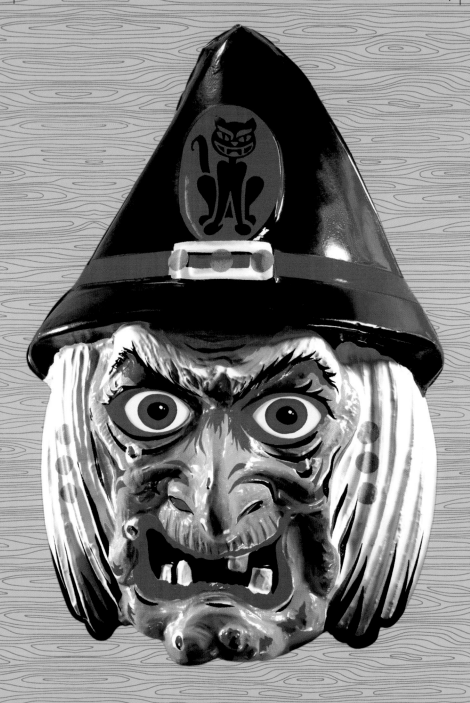

Again, her basic features aren't bad—why does she harm her own cause with that awful chopped hairdo, horrific dental work, and bad makeup? And what does the buckle on the hat actually do?

Grandma is well over 189 years old, but she's still as spry as ever. Every day she walks more than a mile to the local apothecary where she buys powdered iguana liver and mummified snake's tongues. And every Tuesday she reads to kindergartners from a book of ancient curses. She's a pistol, she is.

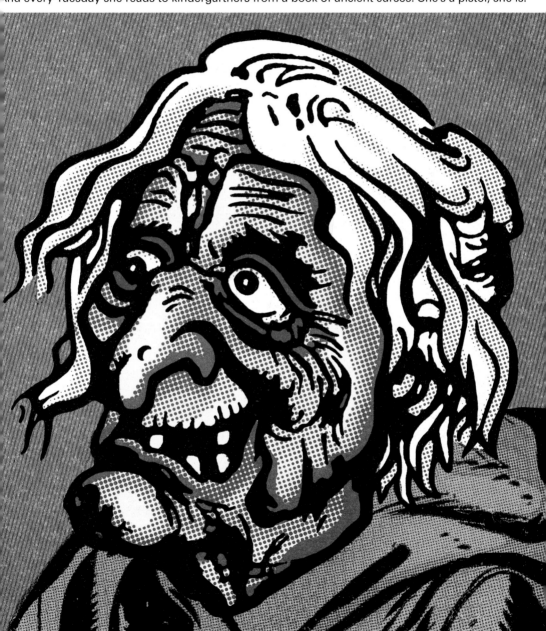

HAUNTED HOUSE

Perhaps no image lurks as darkly in the human subconscious as that of the haunted house. Especially if you're the new owner of that house and you bought it with a thirty-year jumbo fixed mortgage, and you took a bath on the rate due to your less than stellar credit score only to discover that the ghost of a dead grave-digger wanders the halls every night at 3:00 a.m. wailing, clanking chains against your freshly painted walls, and leaving plasma stains on the carpet.

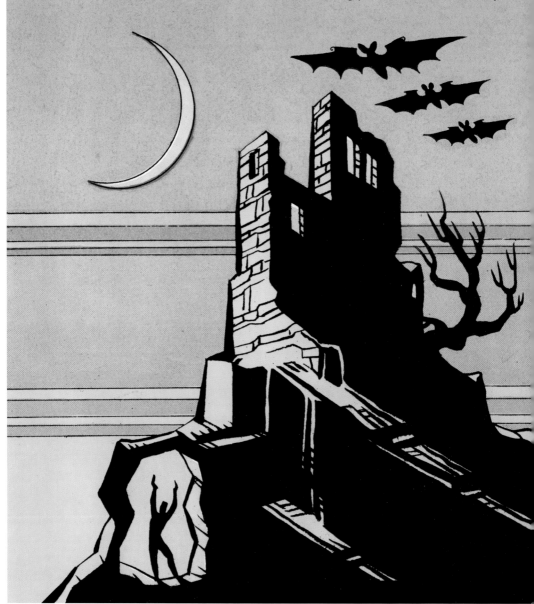

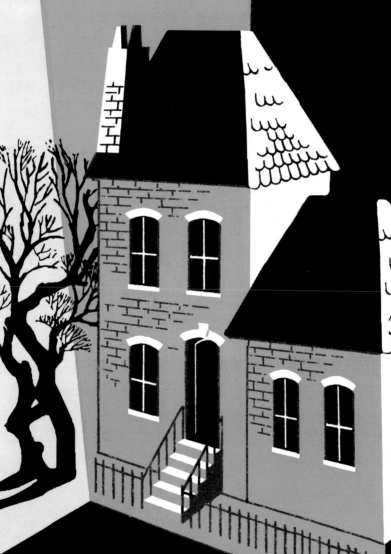

Haunted

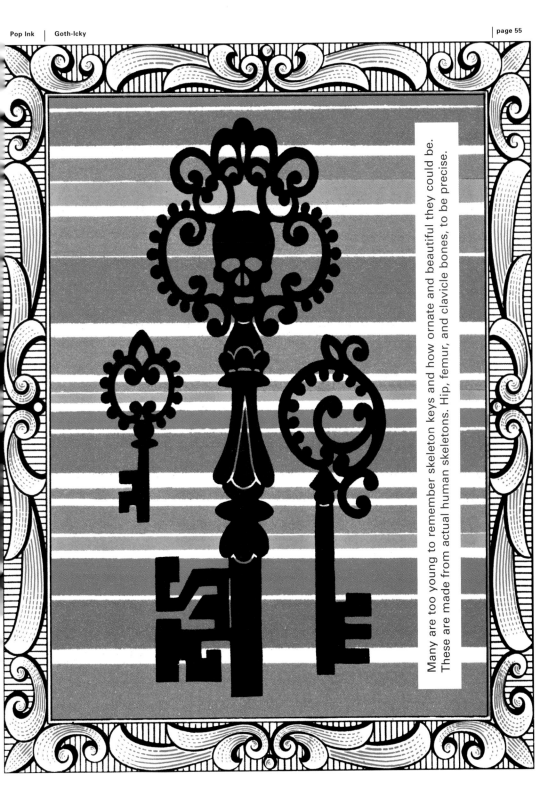

Many are too young to remember skeleton keys and how ornate and beautiful they could be. These are made from actual human skeletons. Hip, femur, and clavicle bones, to be precise.

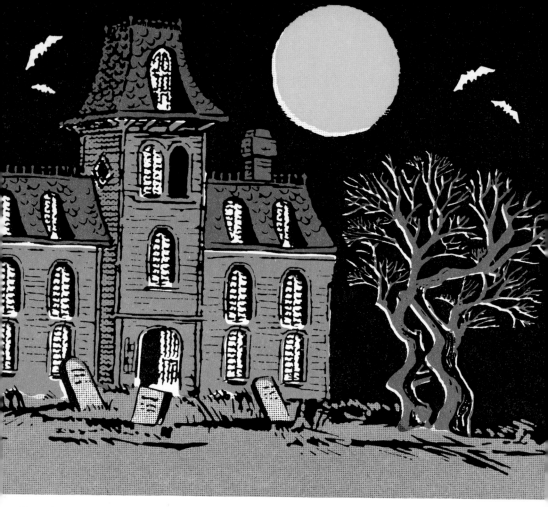

Though tempting because of the enormous income potential, it is still not advisable to put a cemetery in your front yard. First of all, it messes with the water table and you may have to install a very expensive filter to ensure that your drinking water is free from rotting human flesh.

SCARY

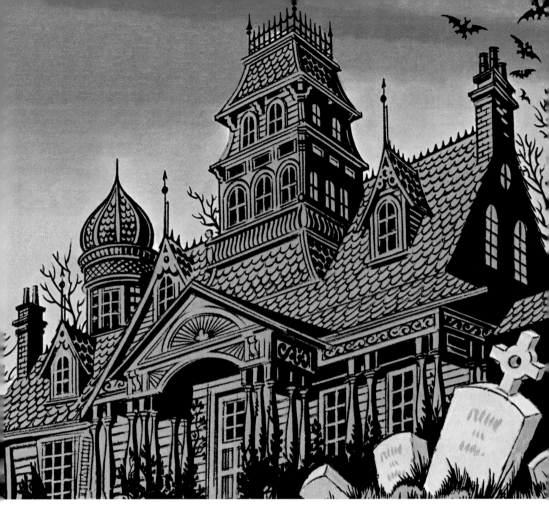

Secondly, it's tough to get a serious touch football game going because your receivers will keep tripping over the headstones. Finally, a small percentage of all corpses turn out to be zombies–not usually a big problem at a distant cemetery, but annoying on your front lawn.

NIGHT

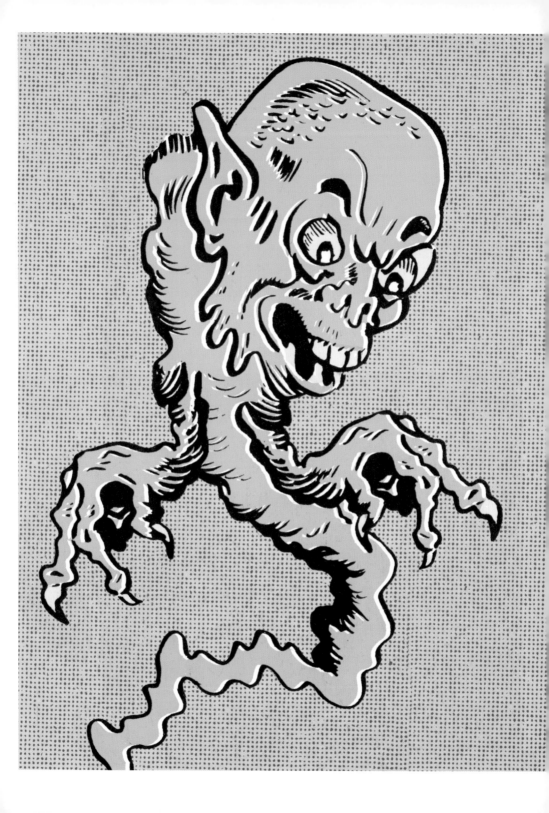

GHOST TOWN

They say the souls of the dead wander the ether, unable to rest as long as they have unfinished business here on earth. These two tough-looking hombres apparently died before they were able to sufficiently frighten a strait-laced tourist.

CHILLING

Cold terror grips your heart. Your veins feel icy, yet a clammy sweat covers your body. Your heart skips and your breath catches as you let out a strangled little scream. At that moment, you vow never again to be in the locker room at the same time as Ol' Nut-scratcher Pete.

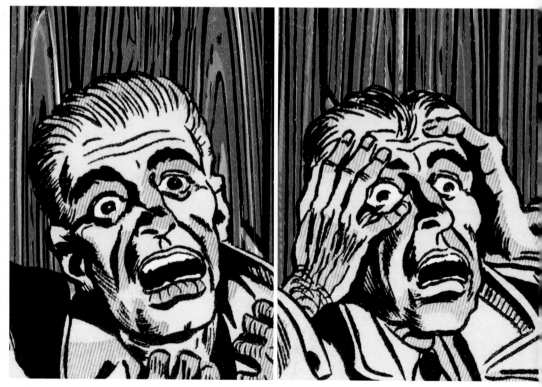

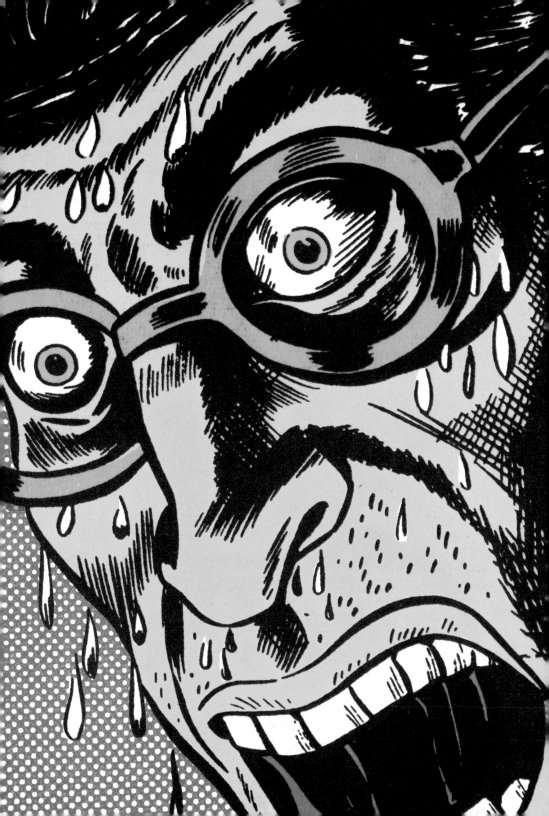

SPIDER

Watch where you walk, my friend. One tiny bite from the deadly black widow and, well, you have a very good chance not only of surviving, but of suffering briefly from mild discomfort.

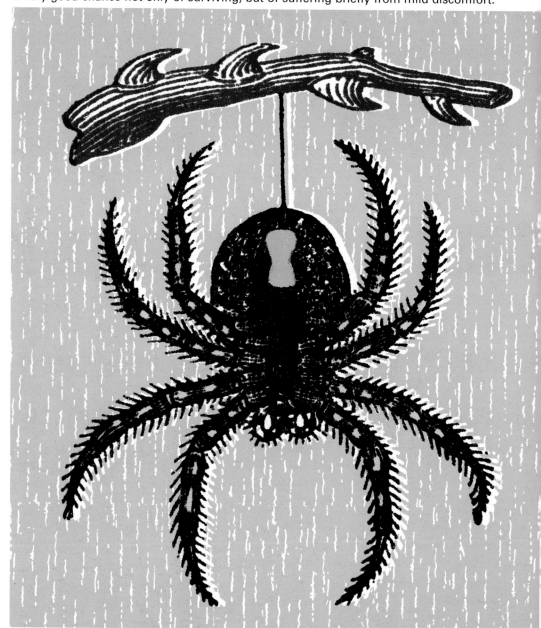

VAMPIRE

According to legend, every night at dusk a vampire rises from hi coffin, grabs a shower and a quick cup of coffee, shape-shifts into a ba and heads off in search of human blood. And if he has any self-respect at all he grabs a shav beforehand and tries to look his best. Are you listening to me, Mr. I-Can't-Be-Bothered-With Basic-Hygiene? Is it time to institute a board of review for vampires, one that can offer certificatio in order to uphold their traditional image as suave ladies' men?

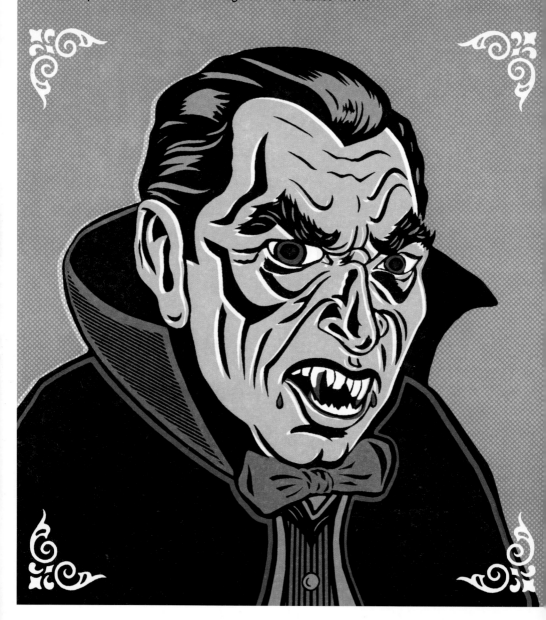

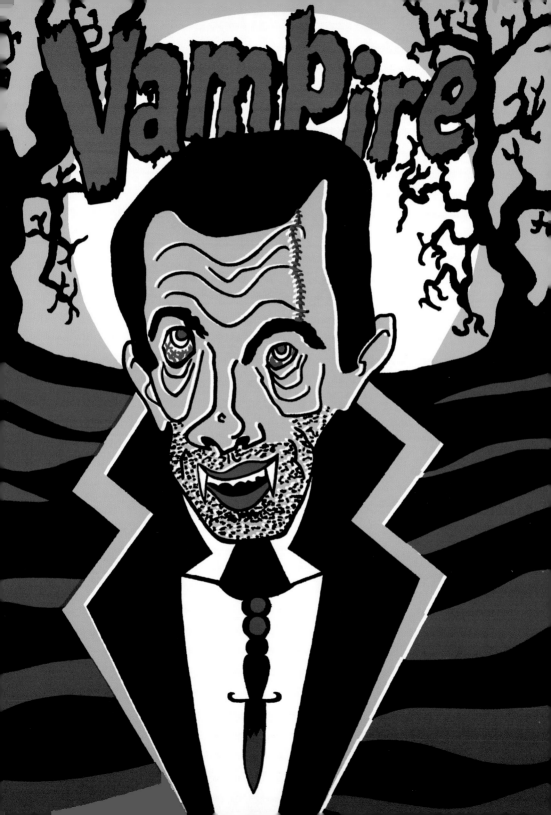

When shopping for a coffin, look for good workmanship and avoid the salesman on the opposite page

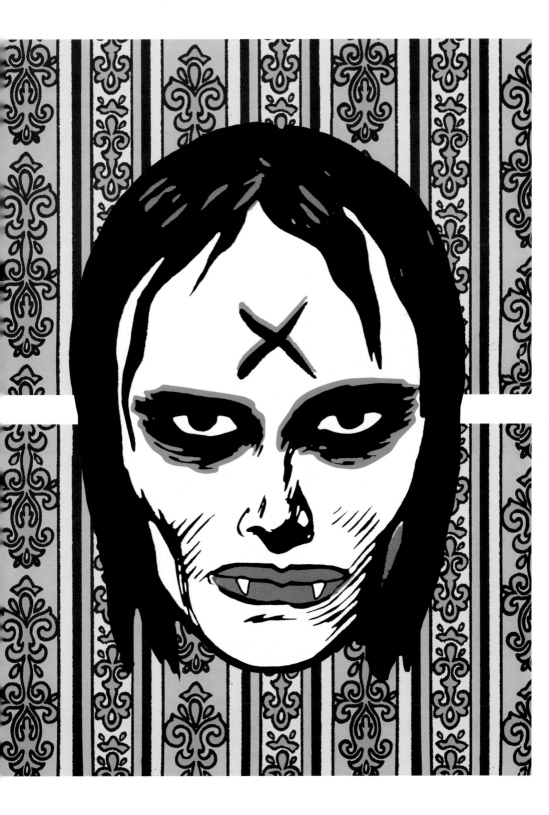

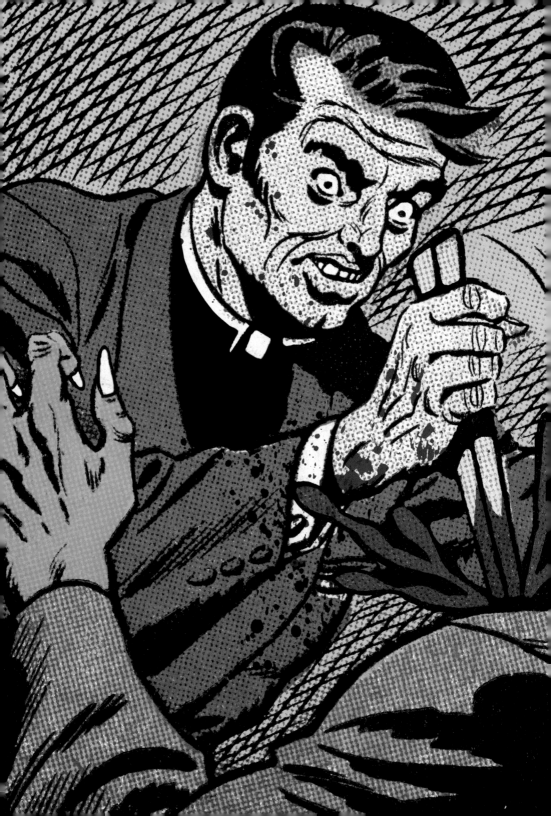

According to legend, the most reliable method for killing a vampire is to stab him through the heart with a sharpened stake. What the legend fails to point out is, that's an effective way to kill anyone. It's a bit clunky to carry around a large hammer and stake, but you can't argue with the results.

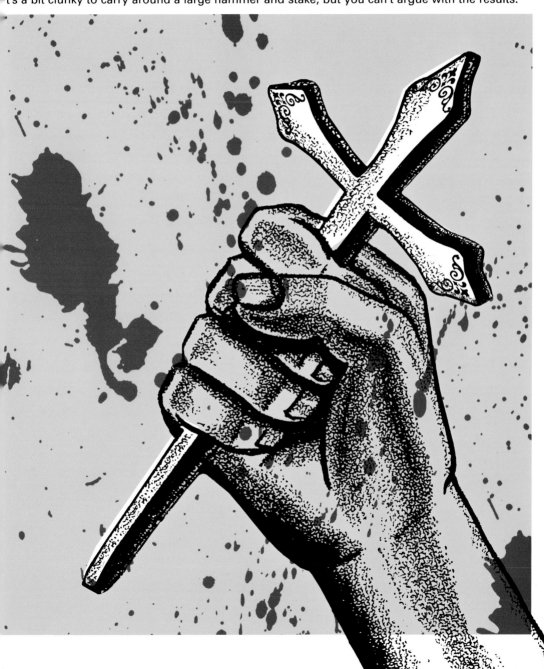

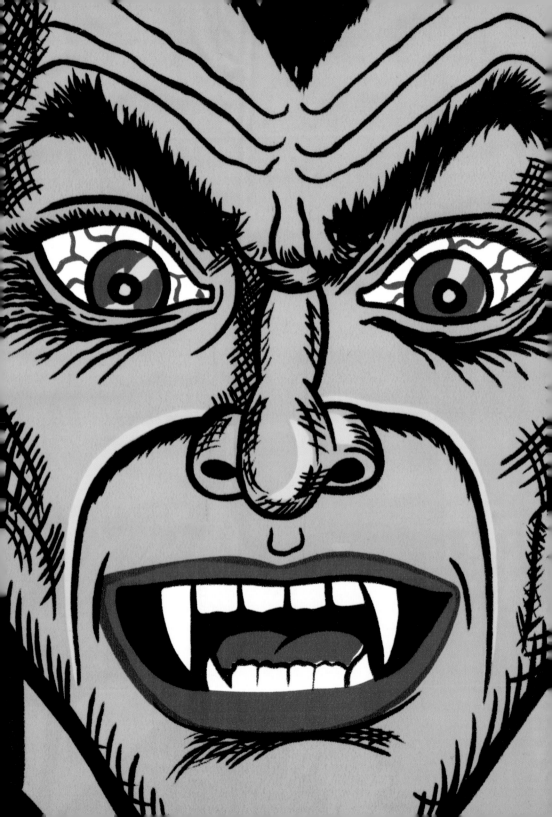

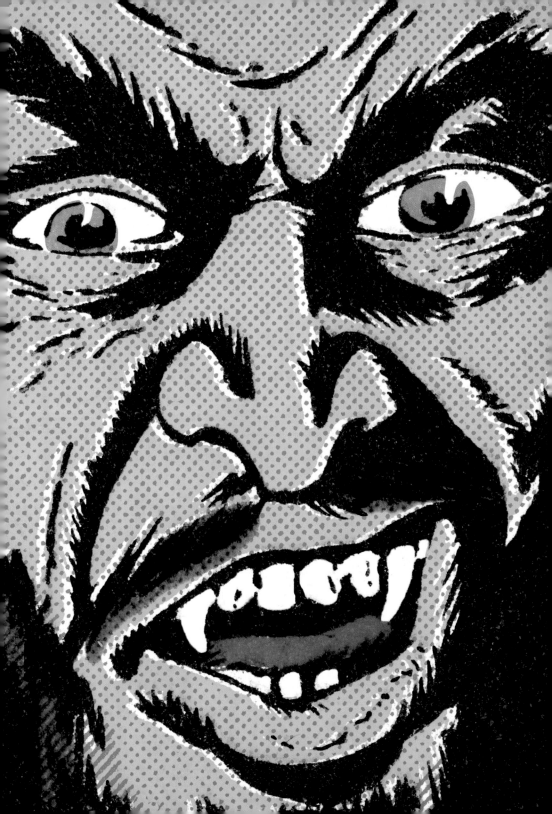

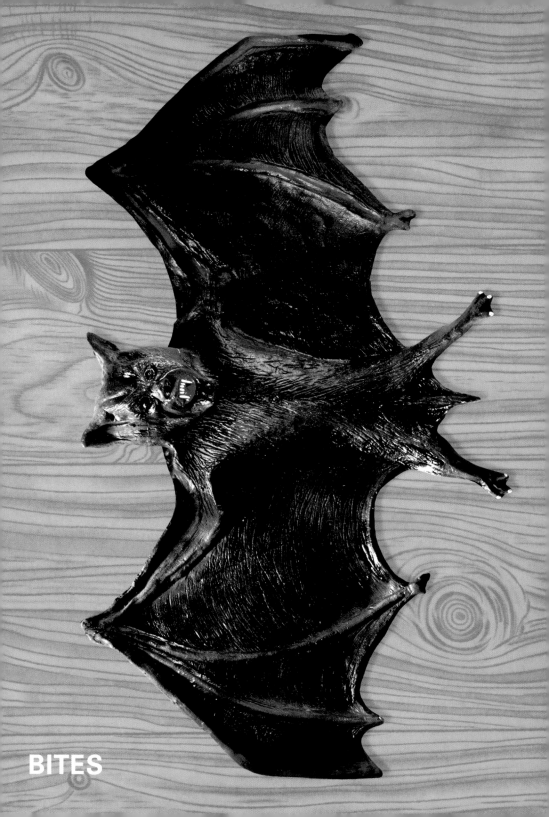

BITES

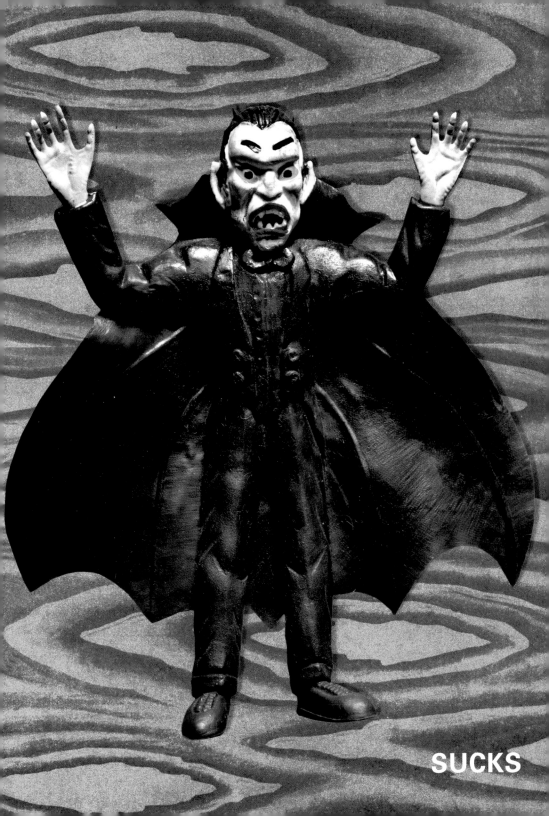

SUCKS

The much-maligned bat is a creature hardly worthy of its bad reputation. It is simply a filthy, tick-infested rodent with creepy translucent wings that flies through the air, stopping occasionally to dig its razor-sharp teeth into the flesh of innocent humans and suck their blood down its slimy throat.

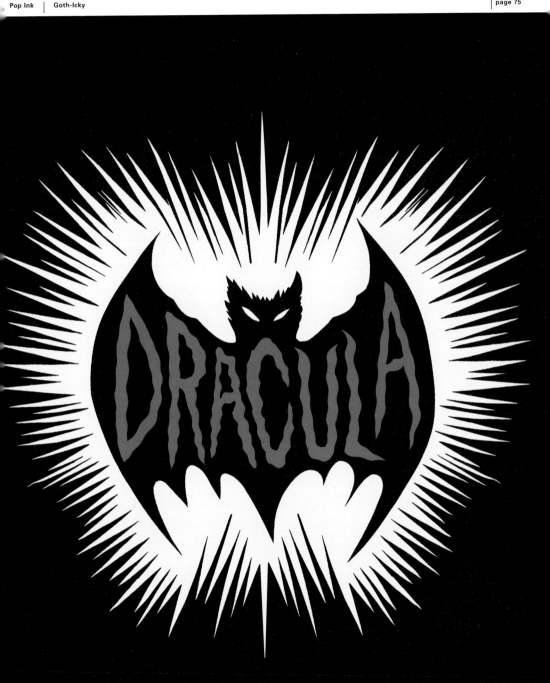

Though vampires are known for their ability to turn into bats, they can also turn into wolves, tigers, bobcats, marmosets, three-toed sloths, leopard moths, capybaras, lice, dung beetles, small shrubs, tree lichen, and most green vegetables. Some transformations are more useful than others.

Vampires must feed regularly on fresh human blood. Though there are numerous reasonably priced Internet sources, most vampires prefer to feed right off the jugular vein of a live human. Because they can't know the blood type of their victims, most vampires have to take several medications to help them tolerate the various types, and they have to watch their blood sugar closely.

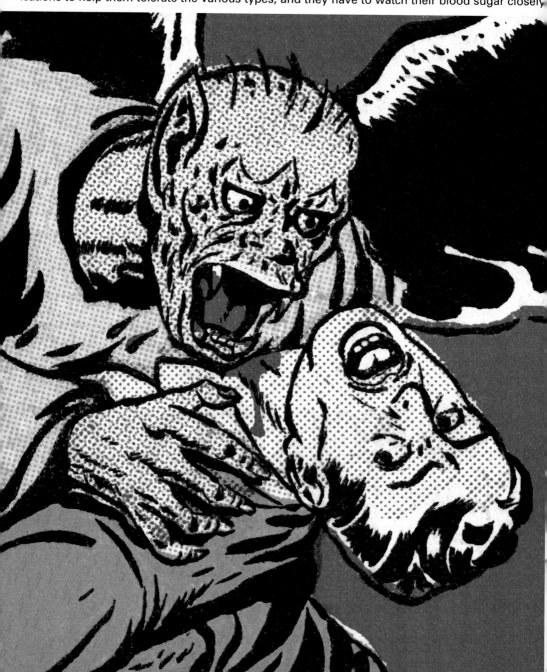

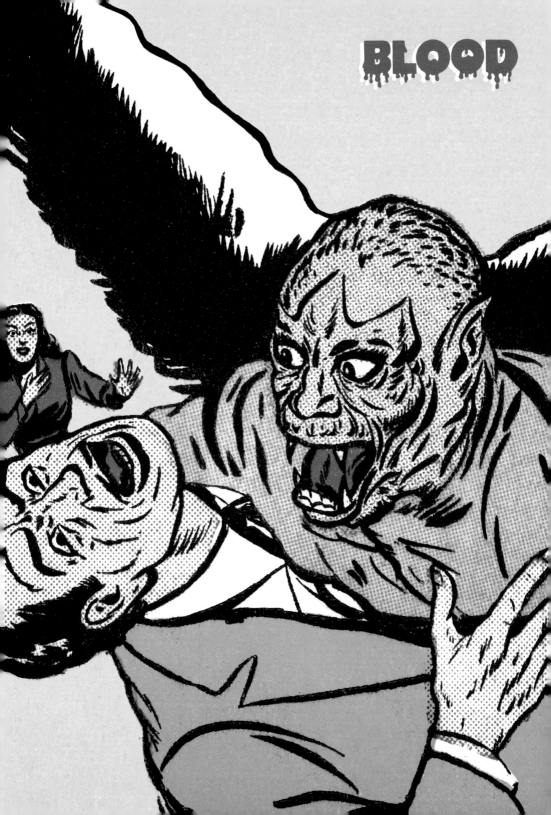

BLOOD

VAMPIRE

The design of vampires' fangs leaves something to be desired. Often, vampires puncture their own lips with their outsized dental work and end up losing a pint or two. Also, their constant shape-shifting means they are continually losing their clothing and can't hold onto sunglasses.

"I never drink . . . wine." These words were spoken by famed Romanian actor Bela Lugosi in the classic 1931 film *Dracula*. This was true not only of the legendary Dracula but of Lugosi himself. However, he never turned down the opportunity to enjoy a nice big mug of heroin.

Blood is low in fat and calories but high in salt and carbs. If you're on a low-carb diet, substitute Clamato, beef broth, or goat's blood. And store your blood in a thermos to maintain freshness.

BLOOD

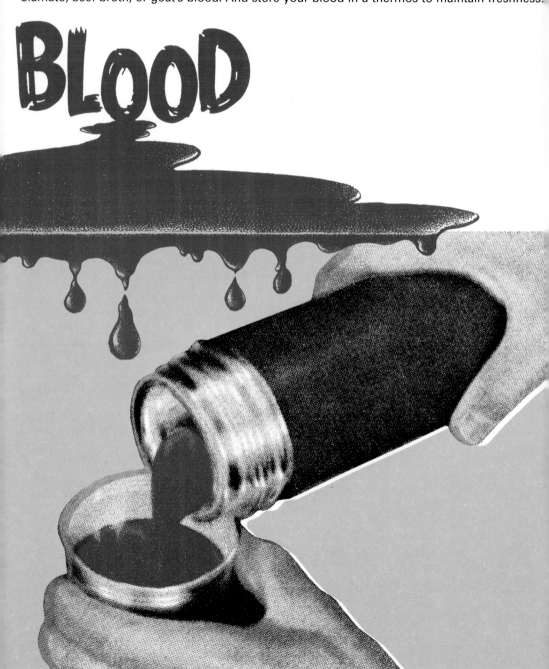

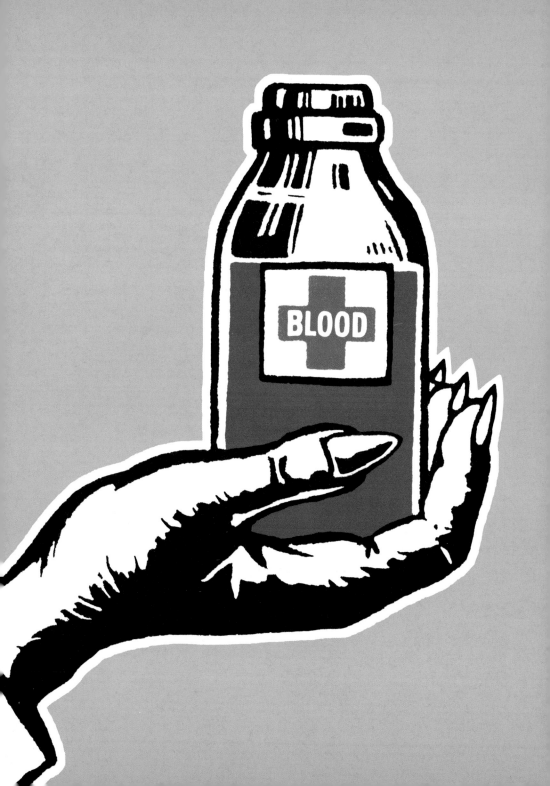

After years of political, social, and personal struggle, the glass ceiling for female vampires seem at last to have been broken. Vampiresses are now harvesting every bit as much blood as their mal counterparts, their coffins are just as ornate, and they are killed by stakes at nearly the same rate

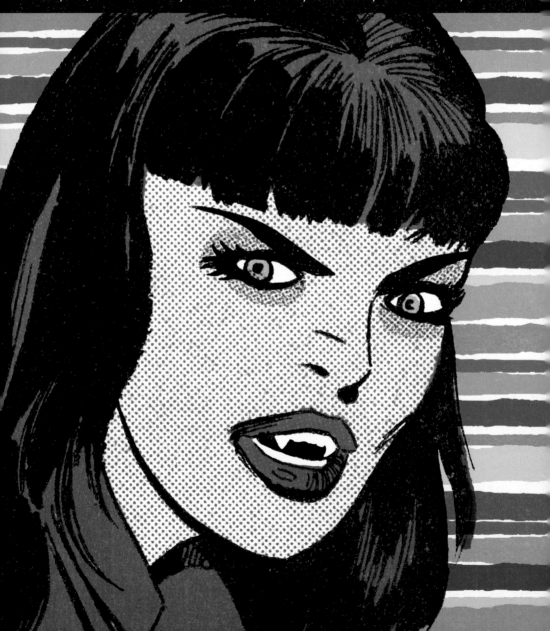

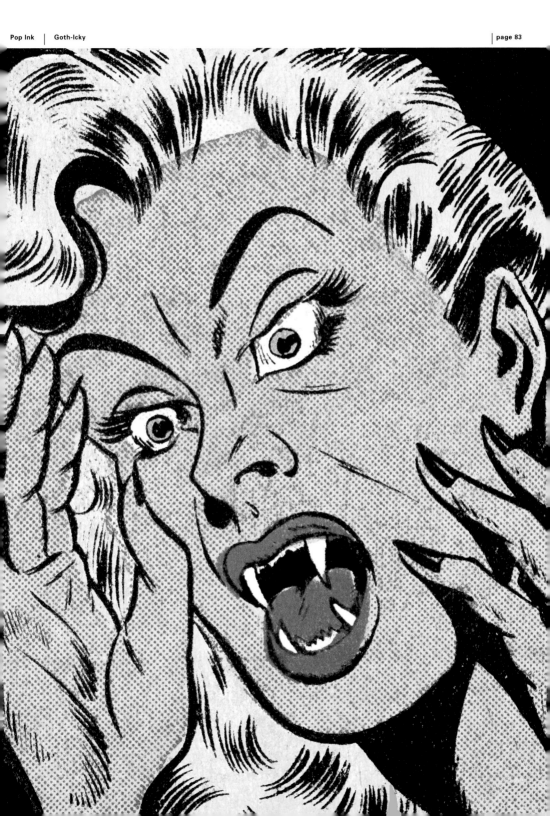

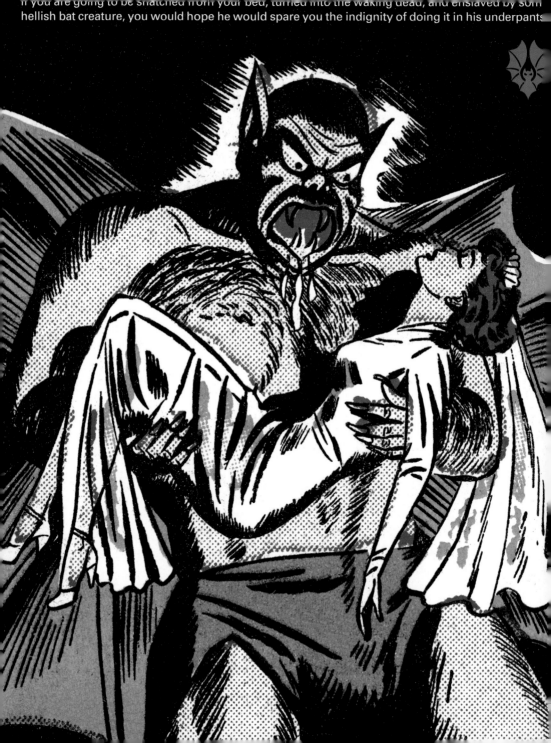

If you are going to be snatched from your bed, turned into the waking dead, and enslaved by some hellish bat creature, you would hope he would spare you the indignity of doing it in his underpants

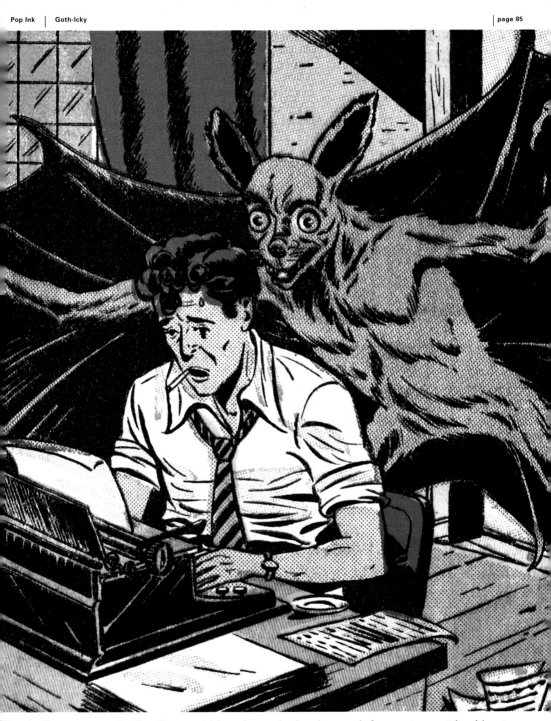

"Look, I've got an early deadline, and it's going to be hard enough for me to meet it without you staring over my shoulder making stupid suggestions like, 'You should put in a thing about a really cool bat creature!' Don't you have something to do? Can you clean the garage until I'm finished?"

ZOMBIES

According to legend, zombies are simply dead human beings who though they share many traits with live humans, lack consciousness (So, like Cher. Kidding! Only kidding!) There are many different varieties of zombies: those reanimated by demons, by disease, by electricity, by aliens, or by the fact they didn't feel like being dead. (The chap pictured below is not a zombie. He just completed a double shift at Taco John's after first downing a twelve-pack of Jolt cola and cranking out a thirty-page term paper on Jacques Derrida for his Contemporary Literary Theory class.)

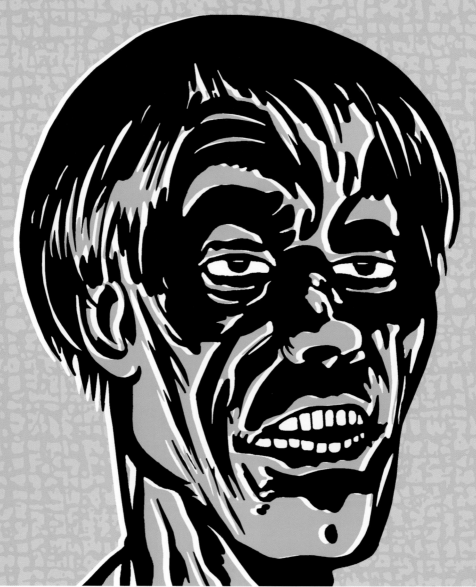

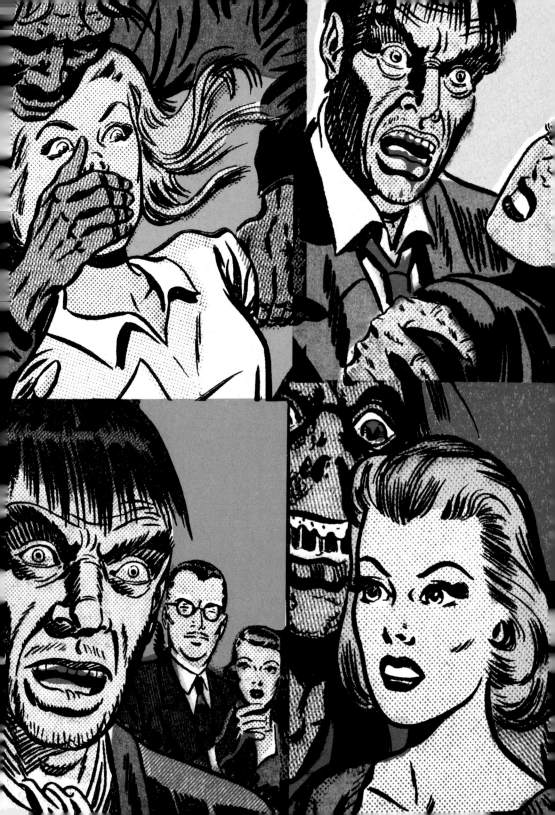

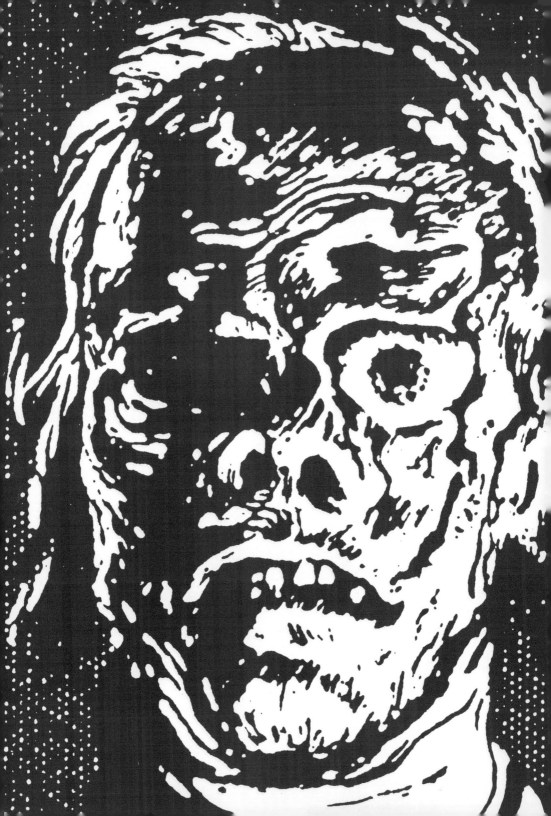

BRAIN

The human brain is a mysterious organ, one of the two most mysterious in the whole human body. Weighing just under three pounds, it contains more than 400 cells (that's just an estimate) and is capable of recalling where you put that little thing that you use to clean the garlic press—at least three times out of four. Oh, and if it gets messed up, you become a zombie.

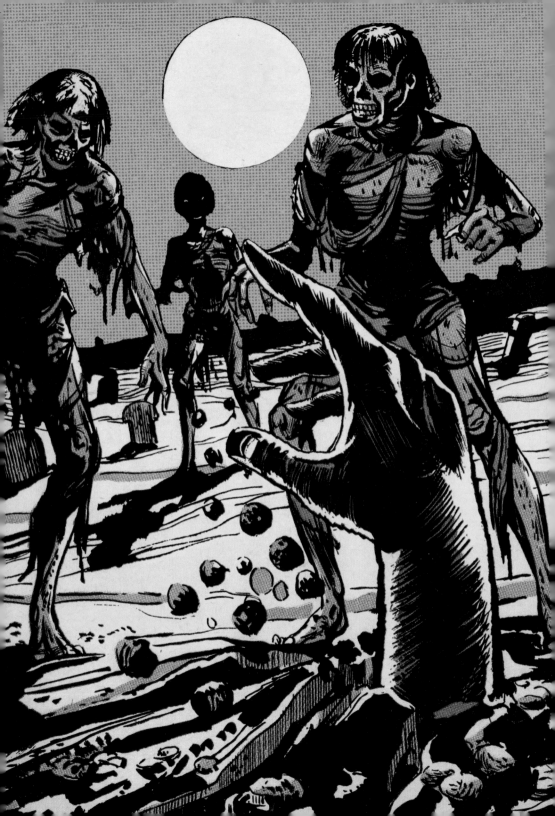

The reason zombies are often seen in various states of decay is that, on average, it takes four weeks to break out of one's coffin and another three to dig back to the surface, a process that tends to strip the decaying flesh right off one's arms and skull.

This fellow's simply got too many irons in the fire to do any single thing very well. Concentrate on the snake, the bat, the shrunken heads, or the black widow embedded in your skull, then move on, OK? Multitasking is well and good, but not if it causes you to suck at every task.

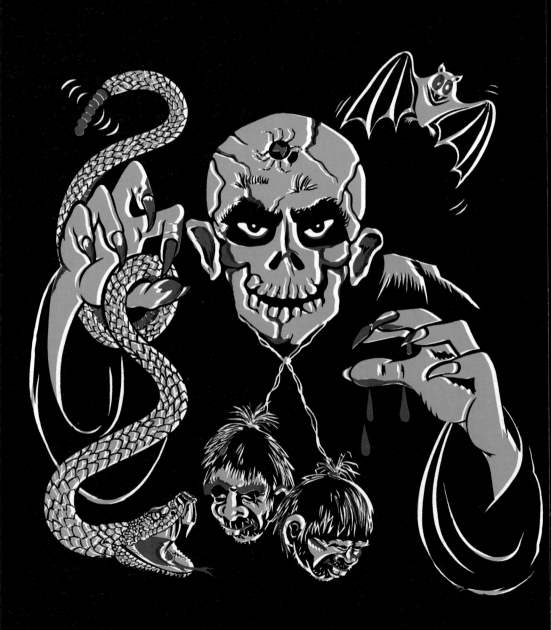

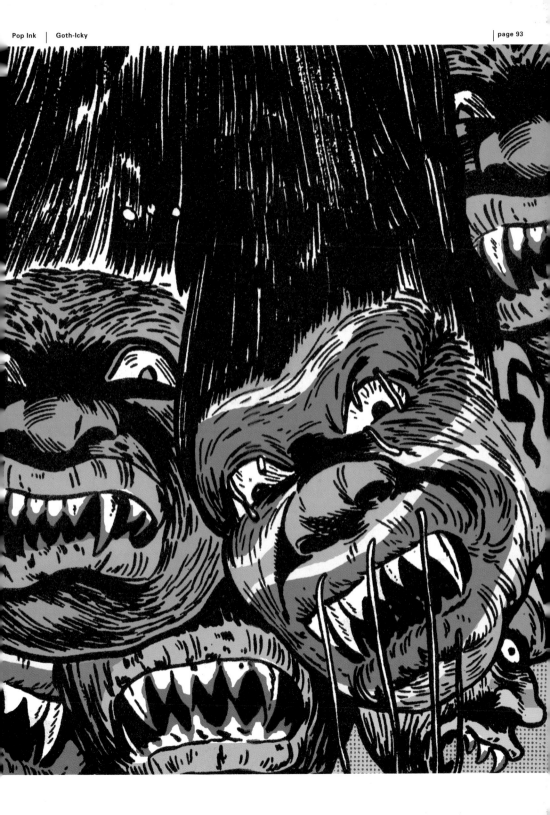

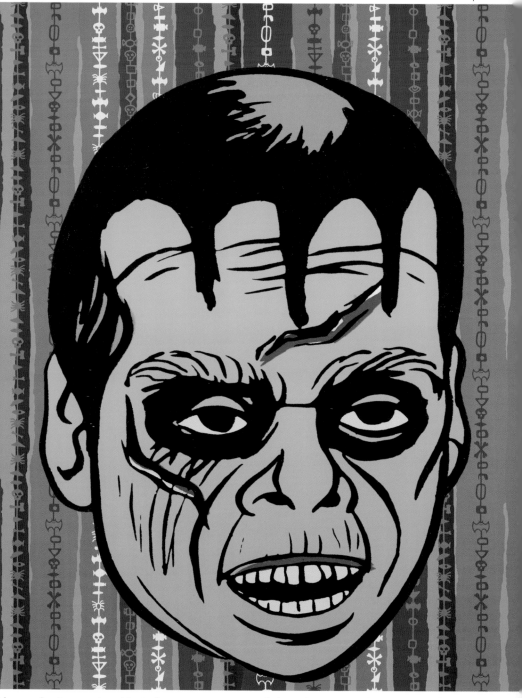

This guy had some trouble trying to open a can of chocolate syrup. First he tried to pry it open with his cheekbone, then his forehead. Let's pitch in and get him a can opener for Christmas.

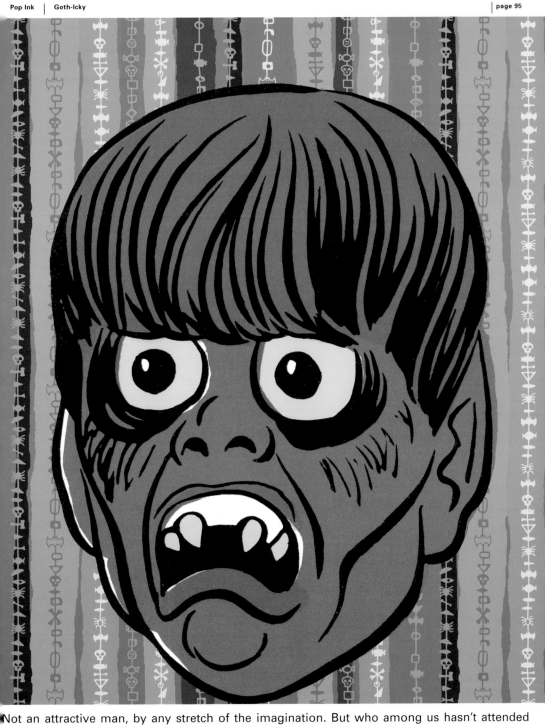

Not an attractive man, by any stretch of the imagination. But who among us hasn't attended grade school with at least one paste-eating, nasally voiced loser who looked a lot like him?

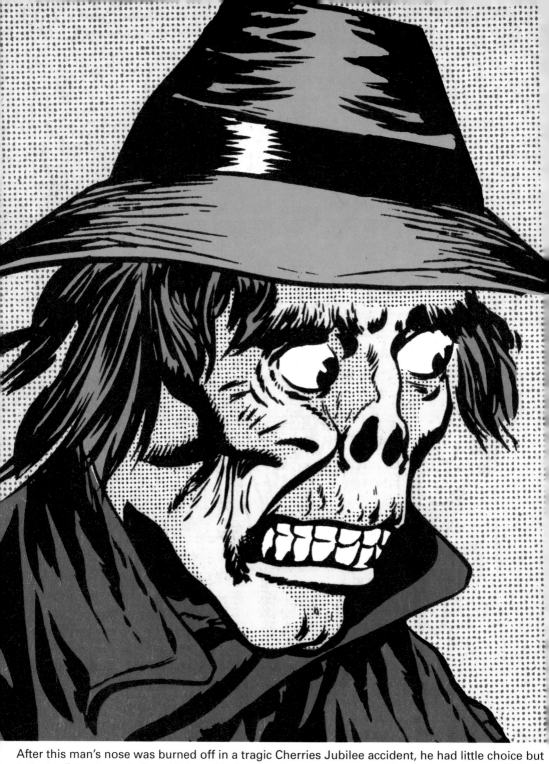

After this man's nose was burned off in a tragic Cherries Jubilee accident, he had little choice but to try to distract people from his horrible features by wearing a snazzy hat and growing out his hair.

Zombies

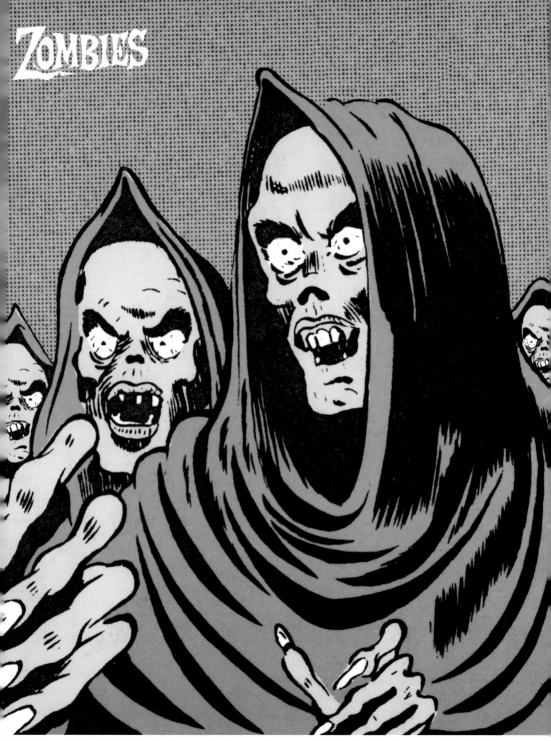

If you ever see a gang of angry zombies coming at you, throw on a poncho and try to blend in with them. Growl, drool, and do your best to look dead. You might also have to eat someone.

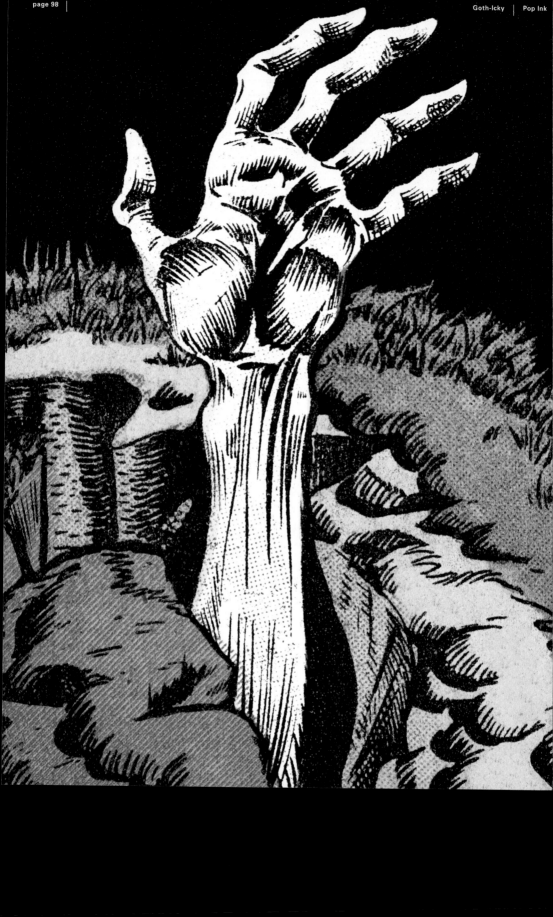

Every skull dreams of hair. Long, beautiful hair. Shining, gleaming, flaxen, waxen, knotted, polka-dotted, twisted, beaded, braided, powdered, flowered, and confettied, mangled, tangled, spangled, and spaghetti, straight and curly, fuzzy, snaggy, shaggy, ratty, matty, oily, greasy, fleecy, shining, steaming, gleaming, hair. Imaginary skull hair. (Sing and repeat until dead.)

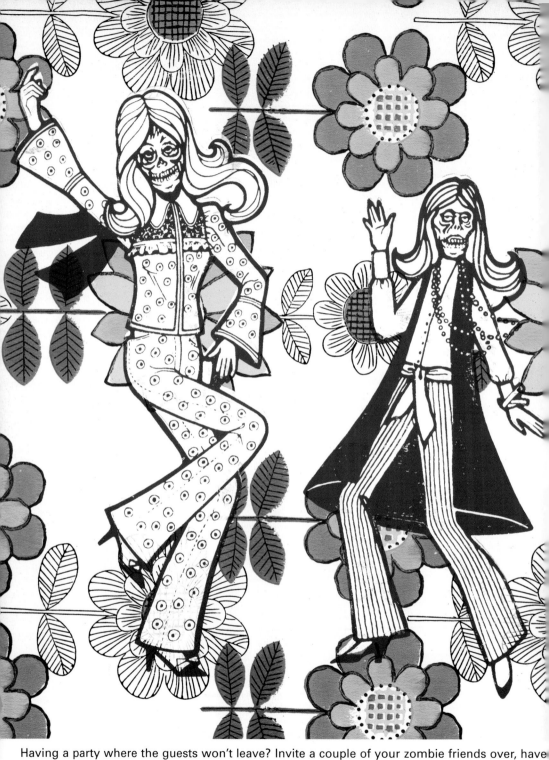

Having a party where the guests won't leave? Invite a couple of your zombie friends over, have them wear their ugliest clothes, and play the Bay City Rollers really loud. It's a room clearer!

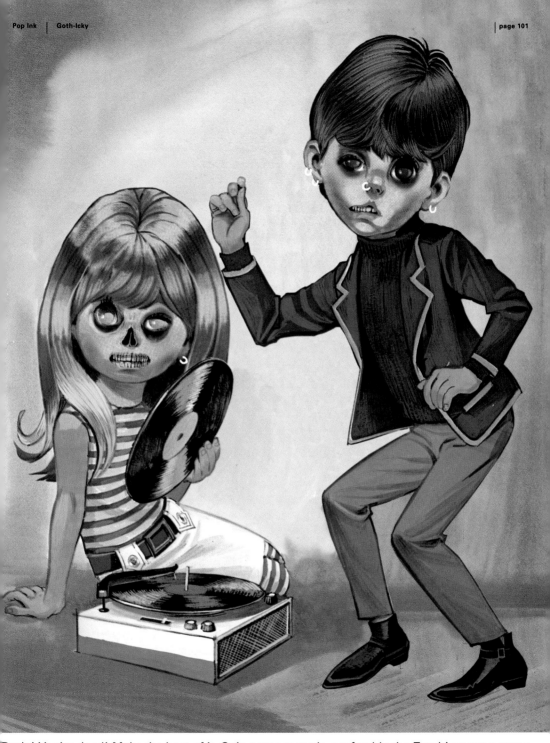

Dude! You're dead! Make the best of it. Spin some records, preferably the Zombies; serve some drinks, preferably fresh human blood; and just chill, so to speak. Lose the boots, though.

Some zombies appear harmless or even friendly and you will be tempted to talk to one of them perhaps have him over for coffee and some Danish and try to understand his point of view and why he is bent on eating your brain. Don't. Simply level your thirty-aught-six and blast the living crap out of his rotting, empty skull. That's the only kind of talking a zombie understands.

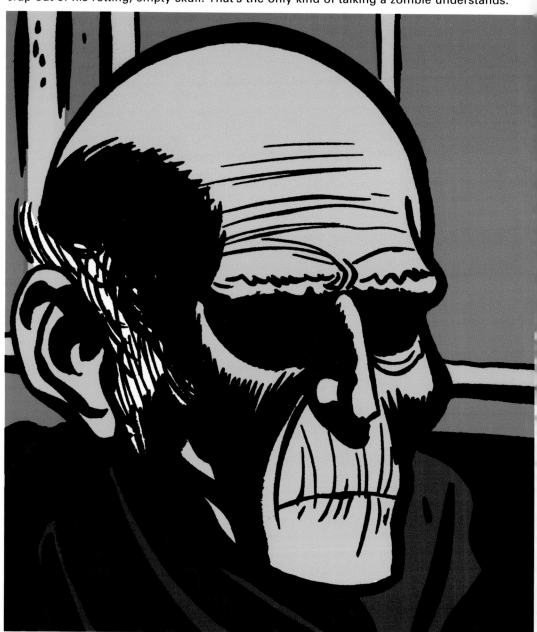

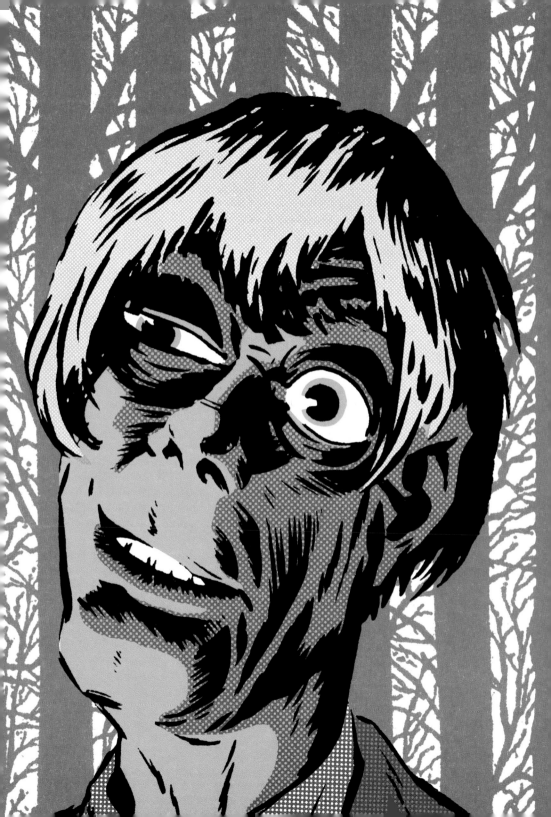

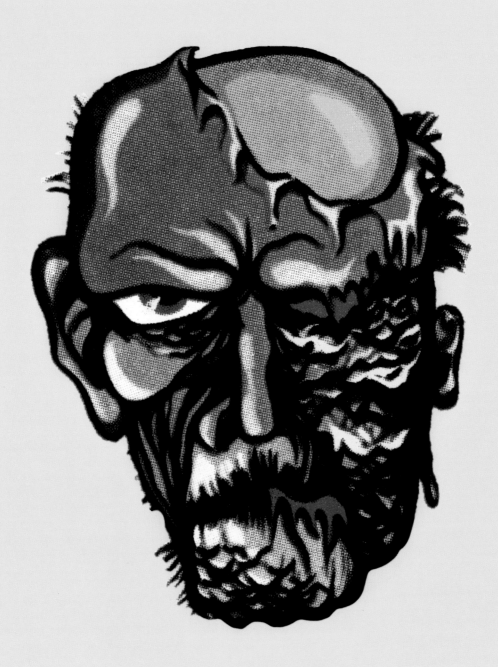

Choose a facial scrub that is well suited for your skin type, whether it's oily, dry, or combination. Otherwise, well, otherwise it could be a touch too aggressive and expose your skull.

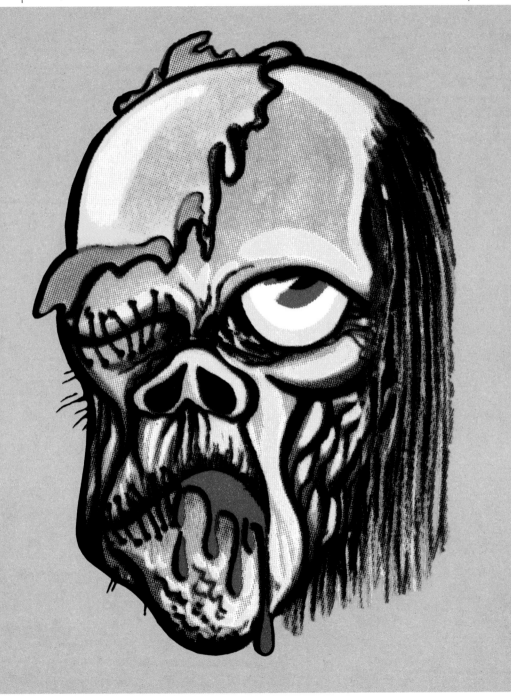

Make sure your moisturizer matches the pH balance of your skin or there could be complications. Your flesh could begin to peel off in great sheets, and you might need to sew your eye socket shut.

GHOULS

Consider the poor ghoul. OK, you've considered him long enough. Frankly, he doesn't deserve any further consideration. Because the ghoul can't articulate how he is different from the zombie. "I'm a ghoul!" says the ghoul helpfully. "I, um, I do all sorts of ghoulish things that are way, way different from a zombie. I, um, creep around at night looking for innocent human victims, which, I admit, zombies do, too. I am undead, basically, which is similar to a zombie, I must confess. I–look, I'm just different, OK?"

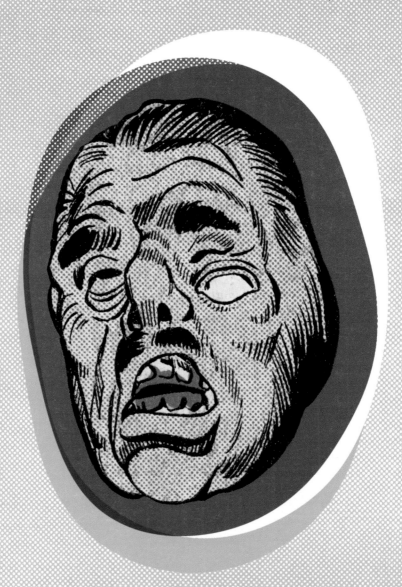

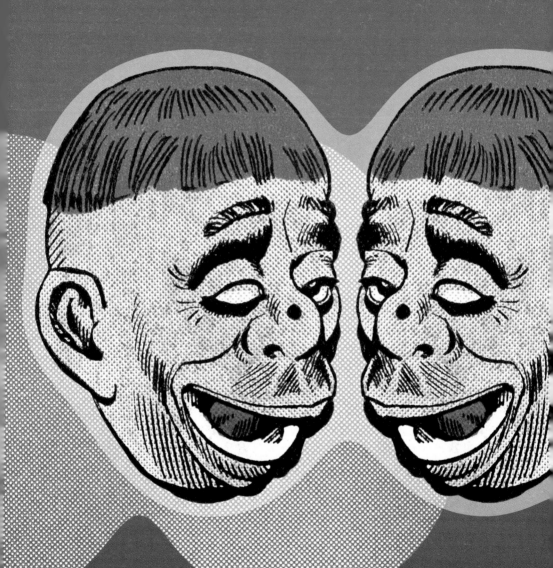

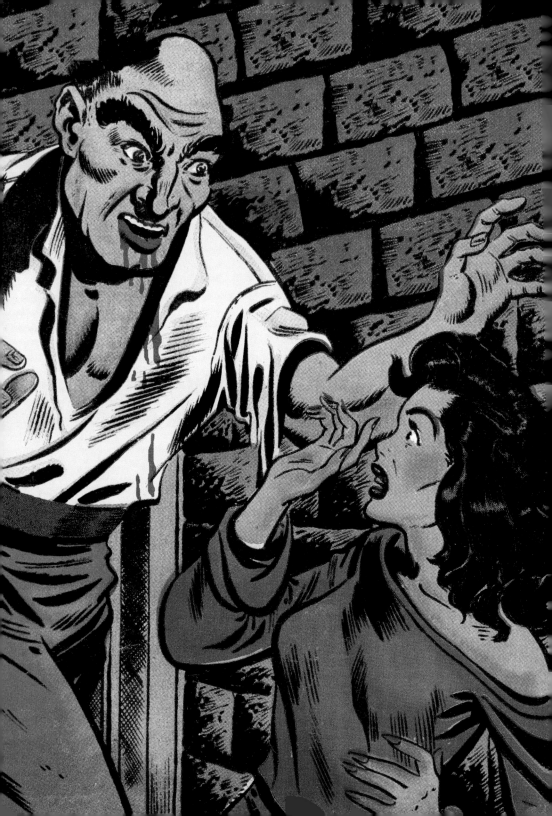

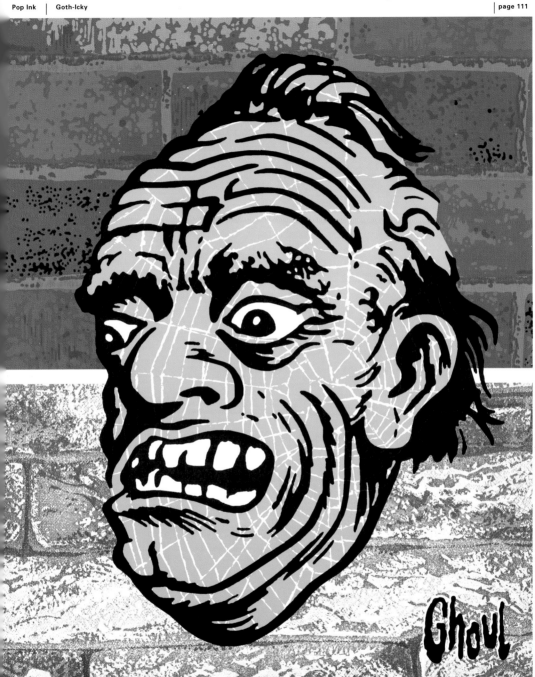

It is difficult if not impossible to tell the difference between a ghoul and a school janitor. You must learn to differentiate the two or it could cost you your life! Ghouls are leering, creepy thugs, prowling the dark places. School janitors are pretty much the same, except they're usually wearing a name tag. Another clue: they're carrying that sawdust stuff that you throw on vomit.

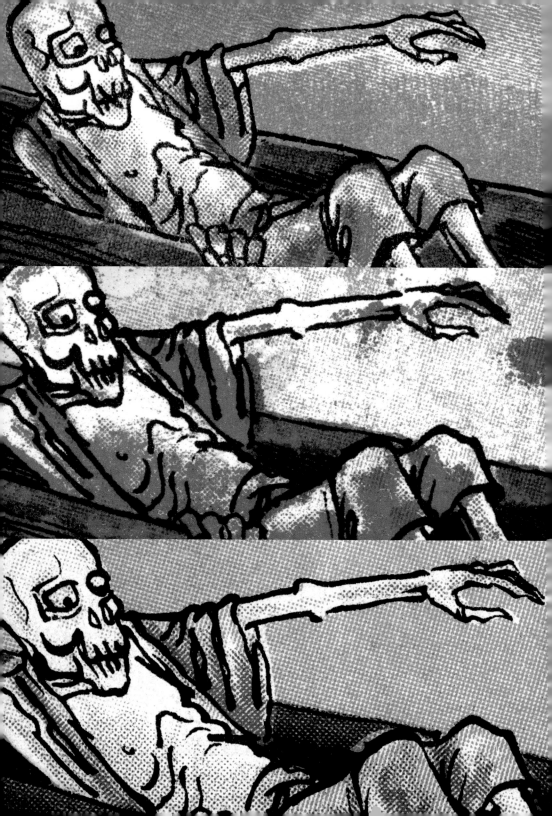

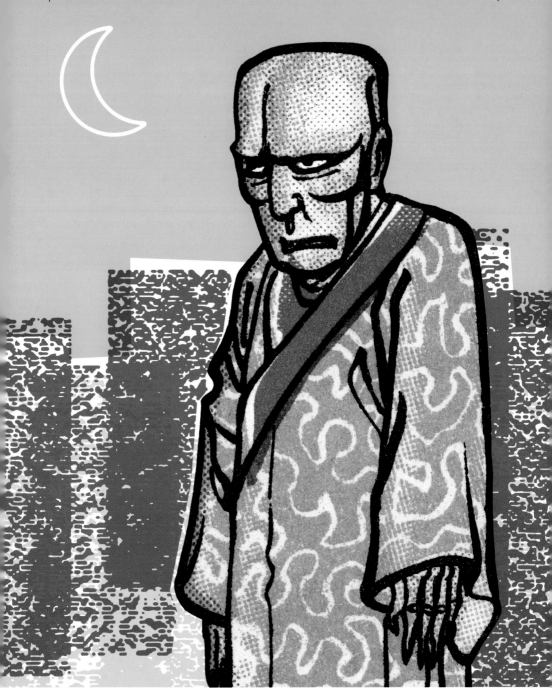

This guy's ticked off, and rightly so. He woke up and discovered someone had shaved off his hair and planed his head into a square. Then that same jerk stripped his flesh and gave him a lousy bathrobe.

Here are two unlucky people who at their own peril chose to ignore the old saying, "If you keep making that expression your face will stay like that." Not so funny now, is it Mr. Butt Ugly?

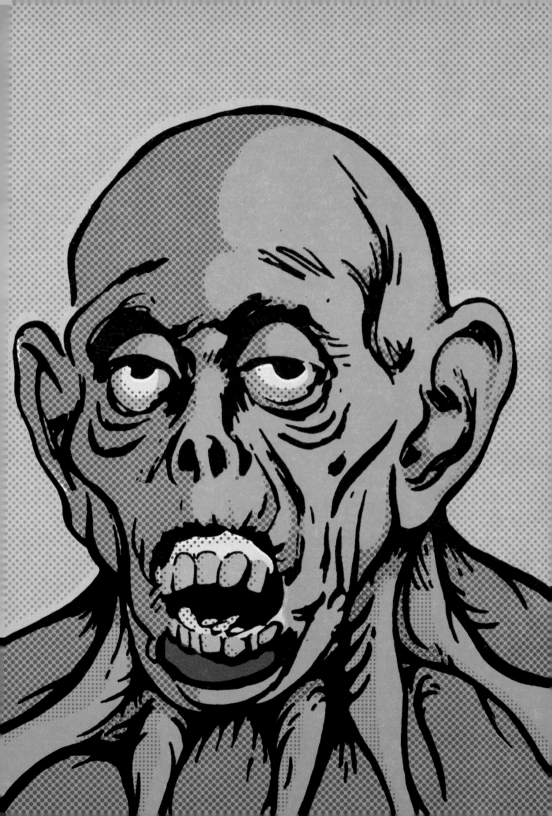

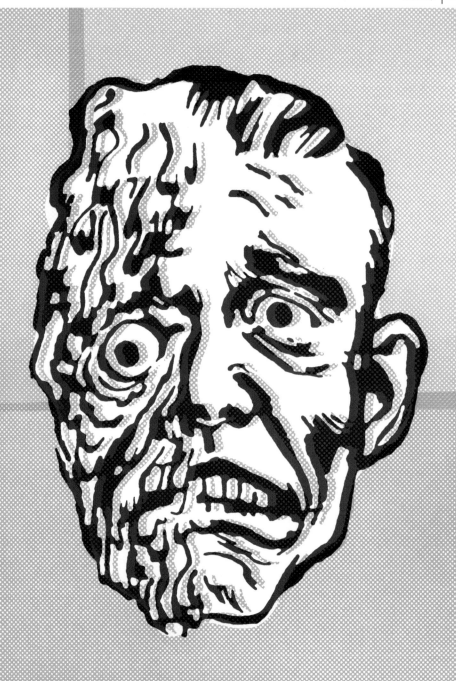

Don't ignore the symptoms of razor burn. Seek treatment right away or watch your face slide off in waxy rivulets. And if you do let it go too long, don't expect to get much action on the home front.

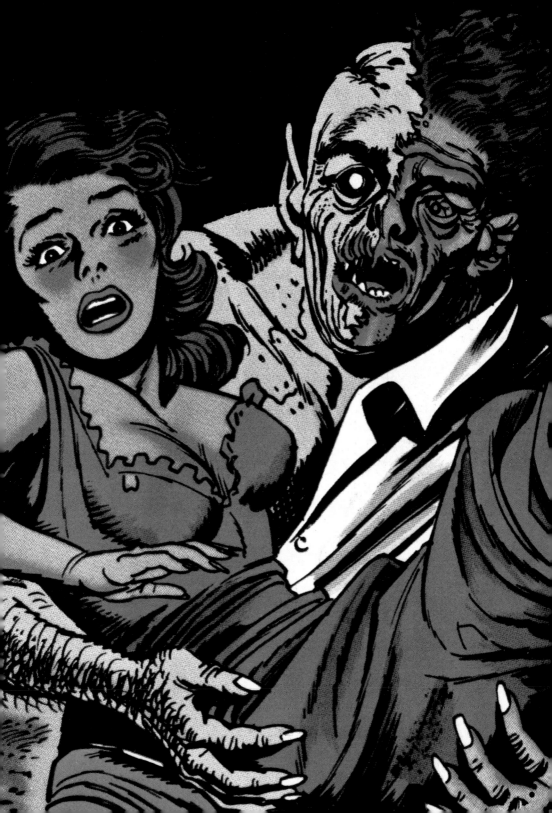

GHOULS

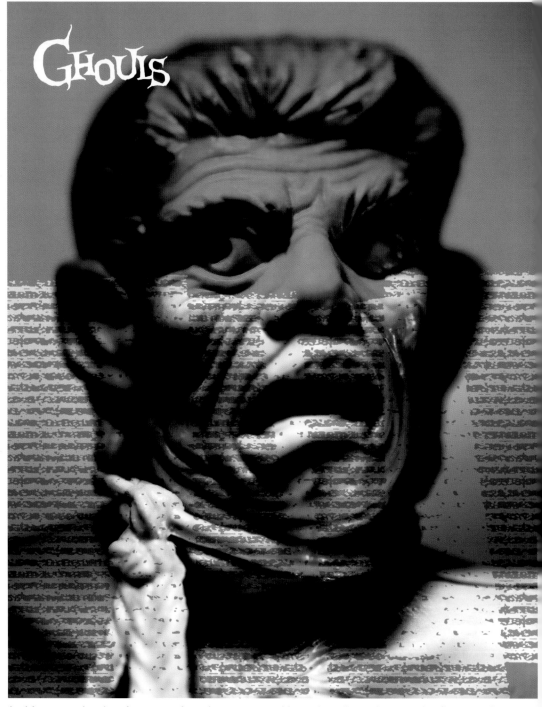

Is this guy a ghoul, or just some haughty gourmand lecturing about the superior flavor and creamy texture of Crottin de Chavignol goat cheese and how well it goes with a saucy Rhône?

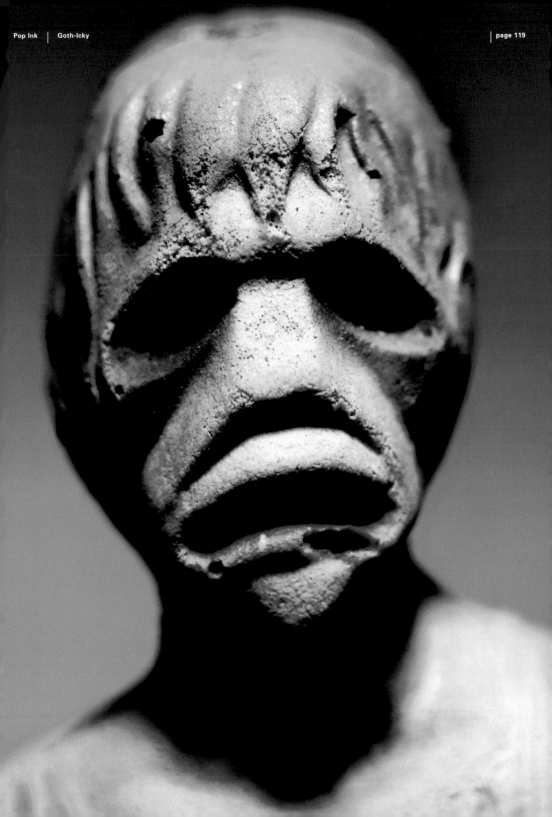

FRANKENSTEIN

He's alive! My creature is alive! He's not looking very good, though. Hope I used the right blood mixture. Don't know why I felt it necessary to countersink those masonry bolts into his skull either. Guess I thought they would give him a certain rugged industrial flair, but now they just look stupid. They'll probably be prone to infection, too, so he'll have to remember to keep them clean–and by the looks of him, I don't think he's really up to remembering much of anything. Drilling that kick plate into his head seems a mistake, too. Oh well, live and learn.

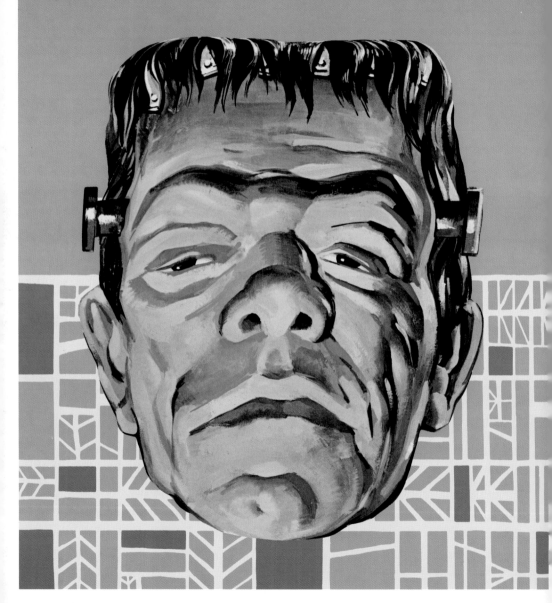

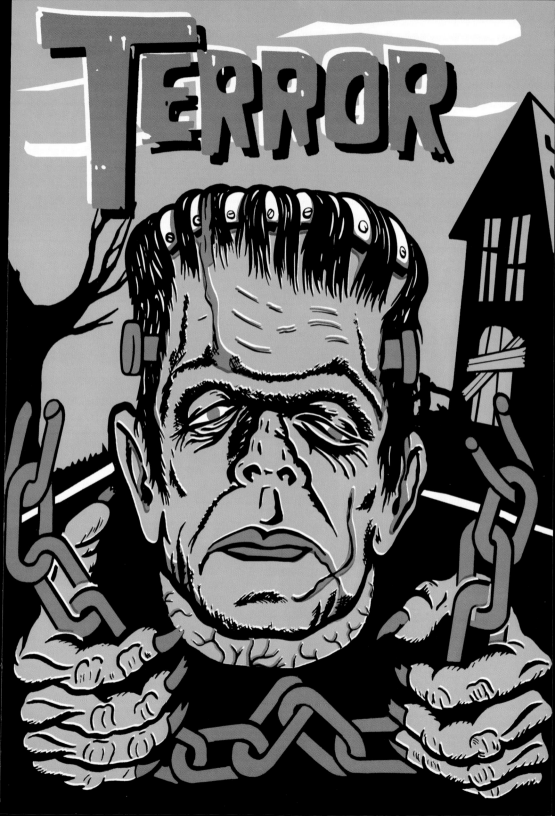

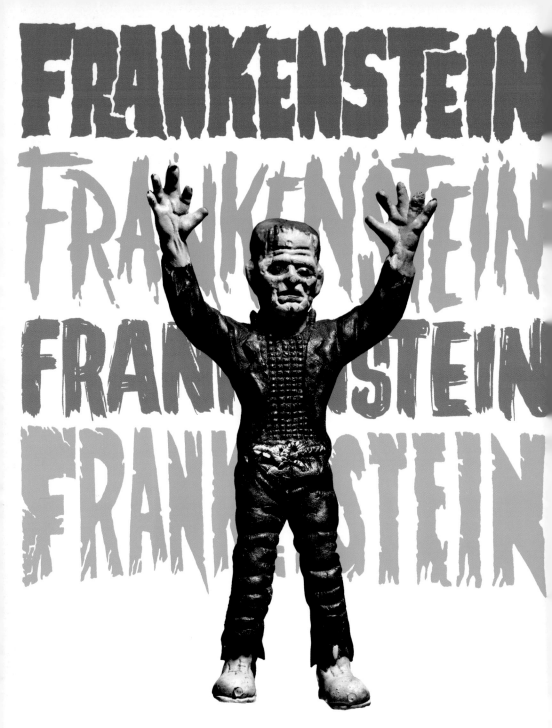

When Frankenstein created his creature, he could have spent the extra four dollars to get him a real used belt at a secondhand store. And was it necessary to suit him up with a shredded pair of pants? Also, try to dress those bleeding wounds, will you? Give the man his dignity.

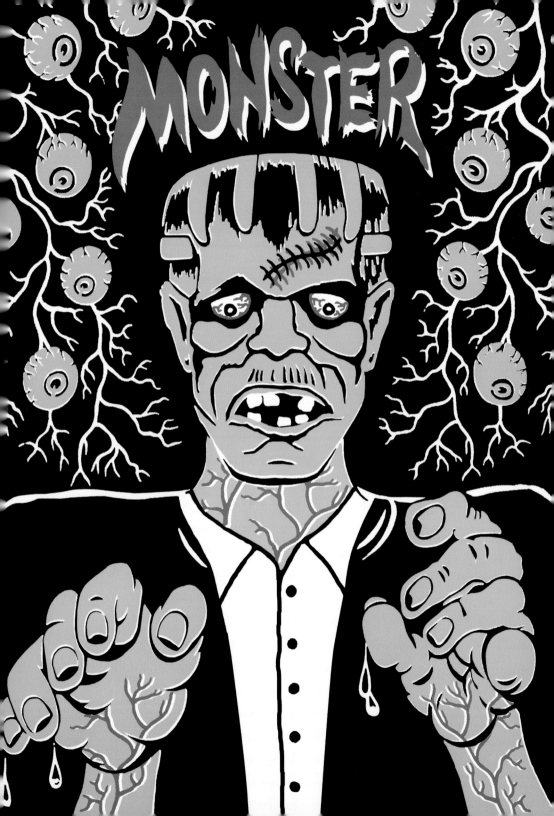

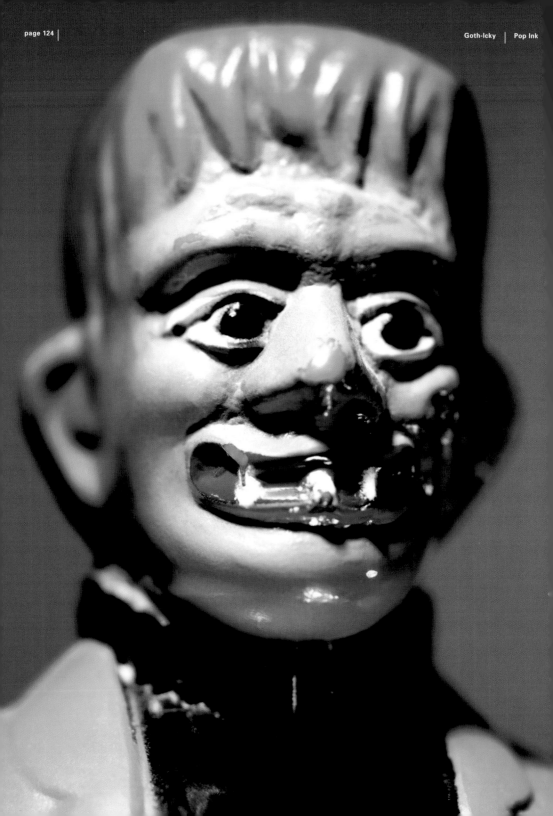

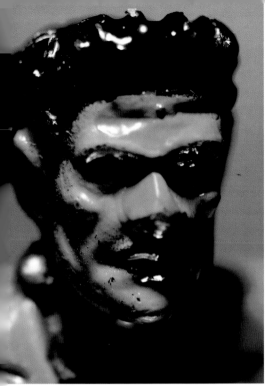
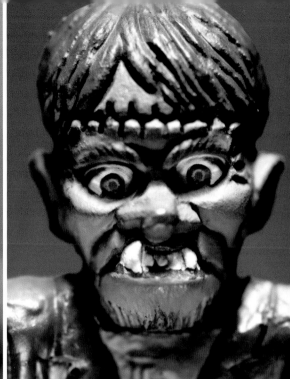

Can't think of a good gift for your eight-year-old niece's birthday? She's bound to love any one of these Rotting Monstrosity Buddies. Collect 'em all! (Or rather, have your niece collect 'em all.)

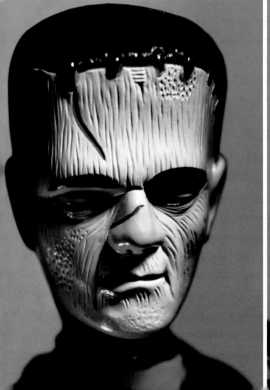
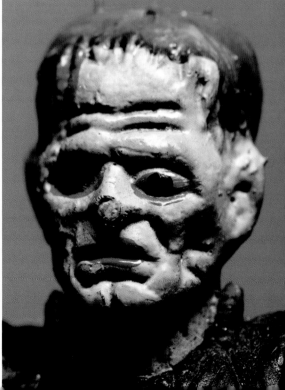

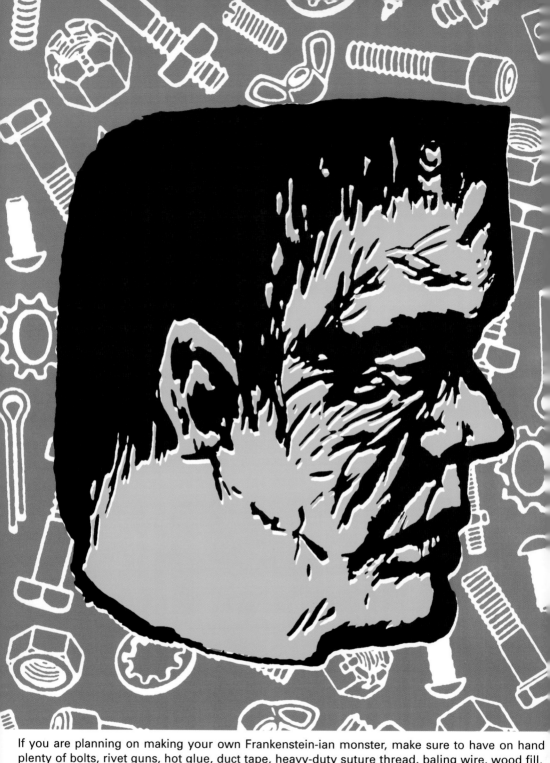

If you are planning on making your own Frankenstein-ian monster, make sure to have on hand plenty of bolts, rivet guns, hot glue, duct tape, heavy-duty suture thread, baling wire, wood fill,

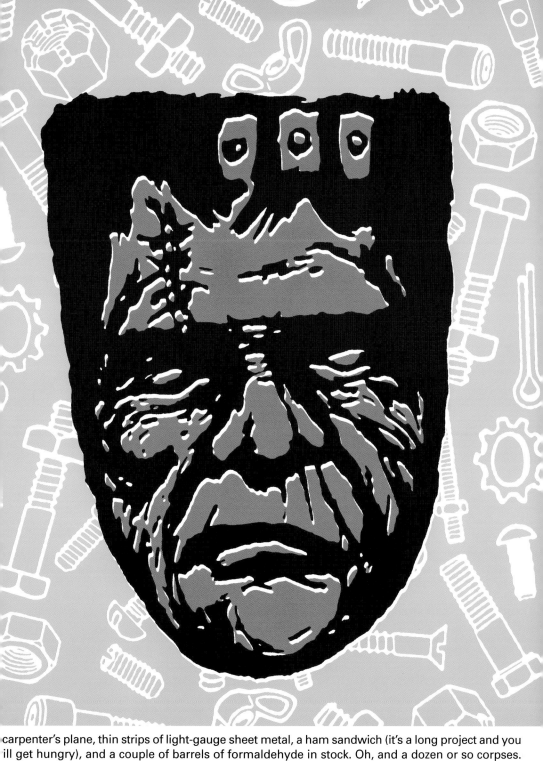

carpenter's plane, thin strips of light-gauge sheet metal, a ham sandwich (it's a long project and you ill get hungry), and a couple of barrels of formaldehyde in stock. Oh, and a dozen or so corpses.

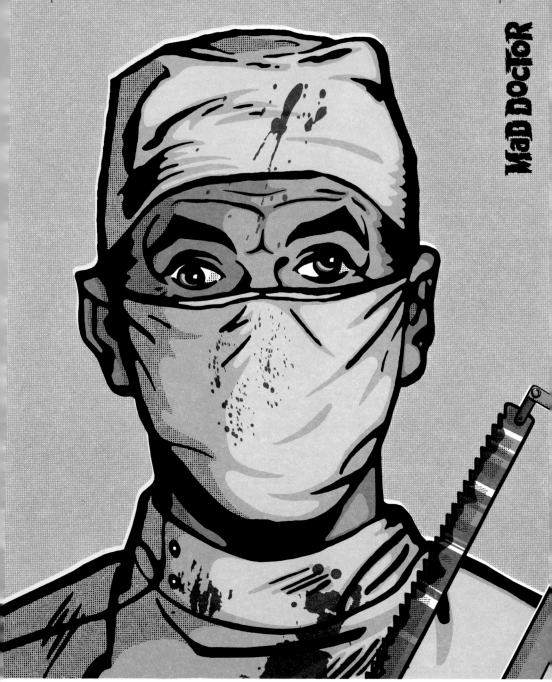

MaD DoctoR

Before choosing a physician, it is wise to thoroughly investigate his credentials, interview some of his other patients, and, certainly, meet with him personally so you can get a sense of what kind of guy he is. If he shows up to your meeting looking like this, you might want to pass him over.

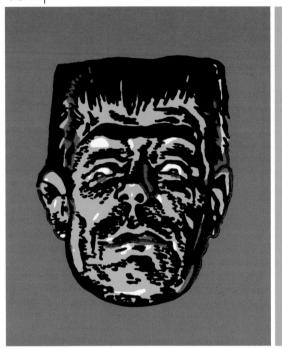 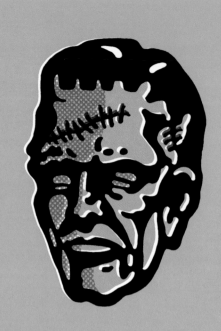

Check out nail head over there. He's grumpy because he fell off a ladder, landed on a nail gun, and drove one into his skull. The others he did on purpose 'cause he kind of liked it.

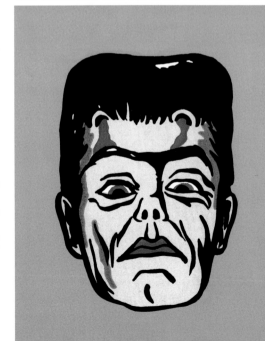 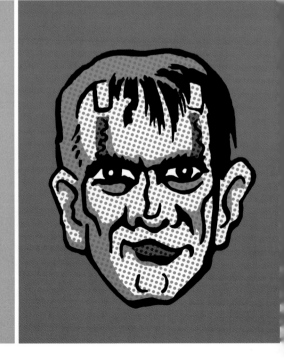

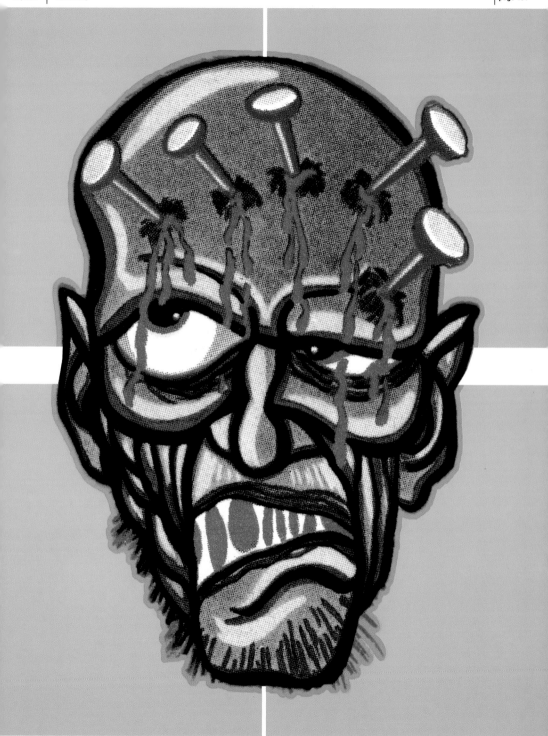

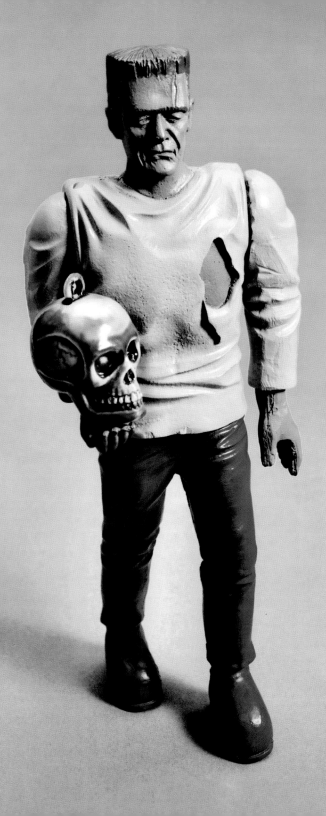

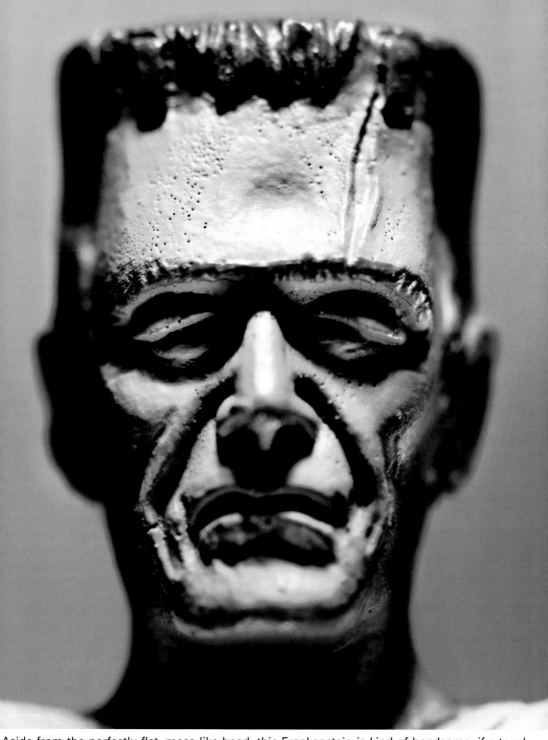

Aside from the perfectly flat, mesa-like head, this Frankenstein is kind of handsome, if a touch plain. I can see how a girl would go for him. He looks a little like Clint Eastwood.

WEREWOLF

The legend of the werewolf originated in Cologne, Germany, in the late 1500s. Peter Stubbe was arrested after a twenty-five-year killing spree in which he ate some people, including his own son. When he was finally caught, he said to the authorities, "I'm a werewolf. Yeah, that's it. A werewolf. I transform into a wolf at night and murder people. It's out of my control." The authorities said, "We believe you," and proceeded to lash him to a wheel and pull his flesh off with hot pincers before decapitating him.

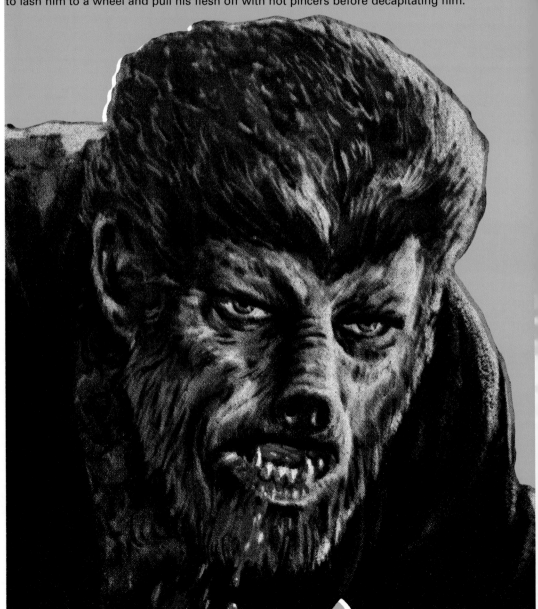

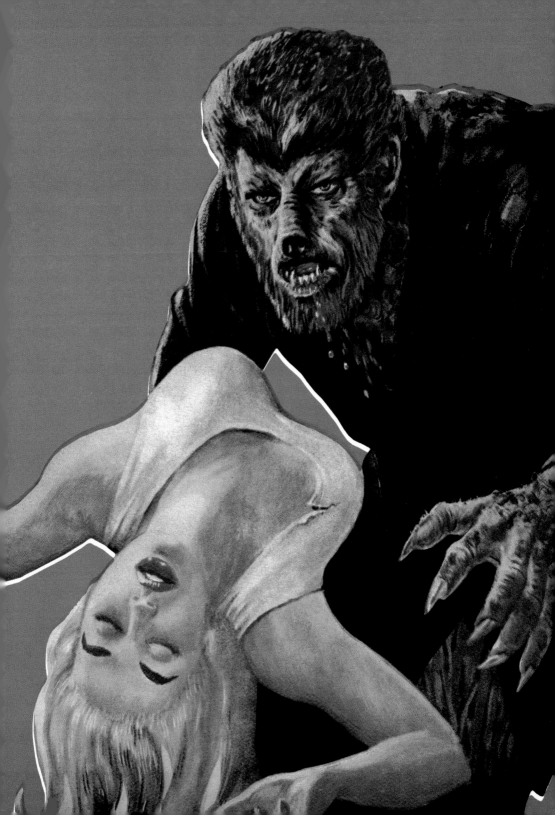

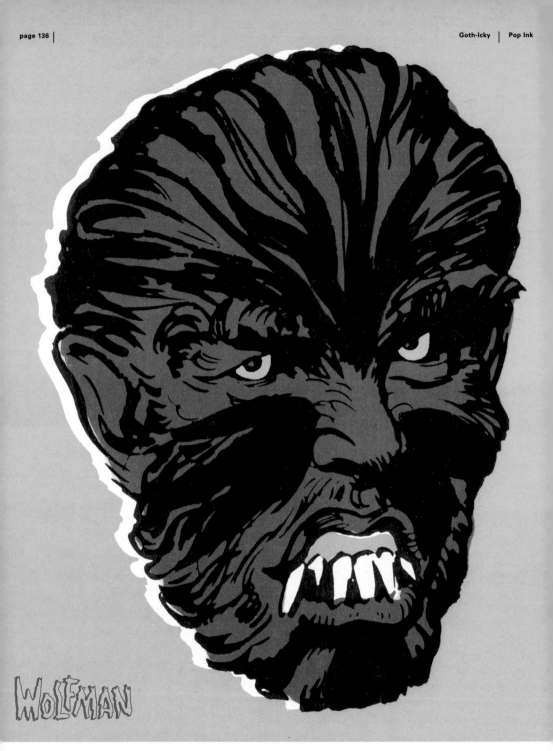

To kill a werewolf, you must shoot him with a specially prepared silver bullet.

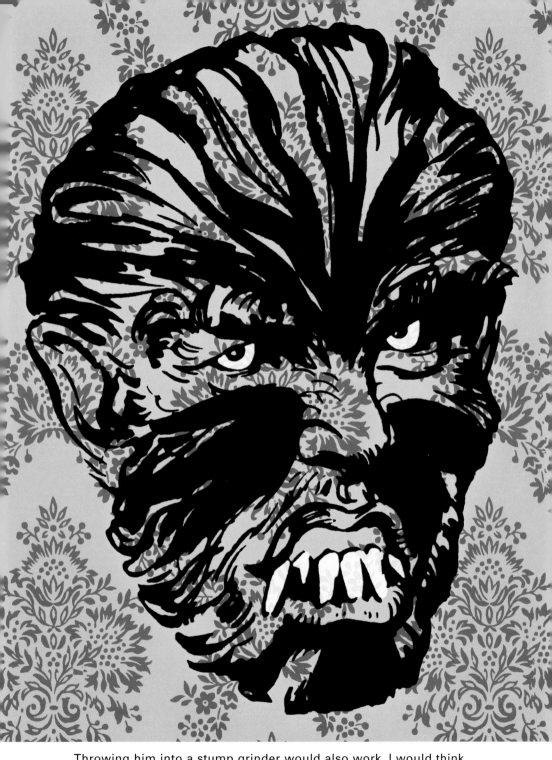

Throwing him into a stump grinder would also work, I would think.

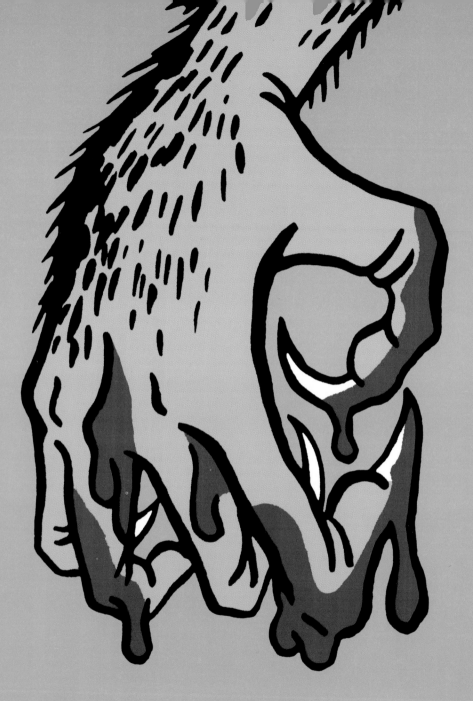

WEREWOLF!

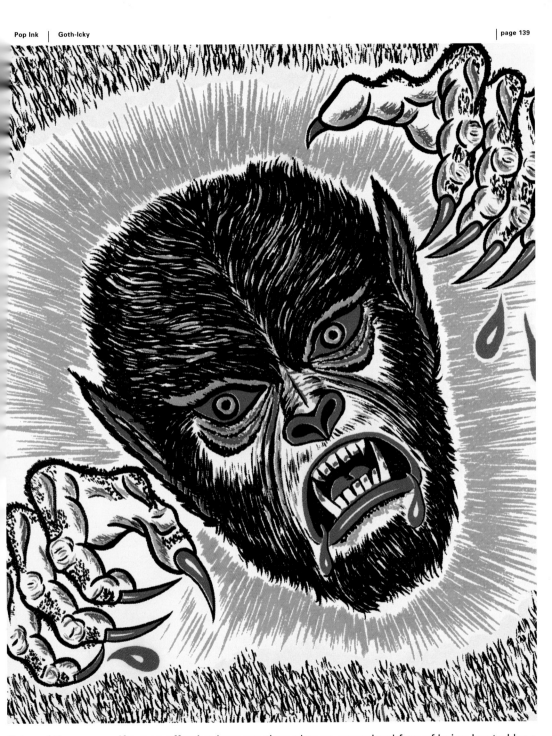

Tales of the werewolf are so effective because they play on our primal fear of being hunted by a wild animal. They also play on our primal fear of hairy men. Ninety percent of Americans have at one time or another had nightmares in which they were accosted by a naked James Brolin.

Not as well known, but no less fascinating than the legend of the werewolf are the legends of the fearsome were-monkey (top left) and the insufferable were–Billy Squier (bottom right).

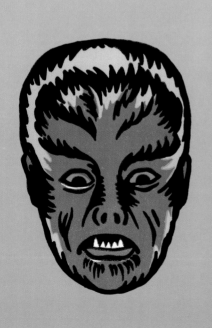

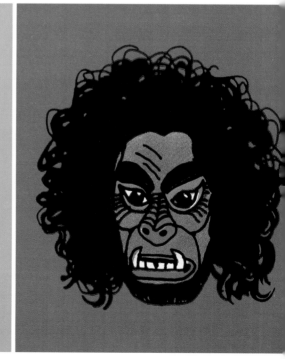

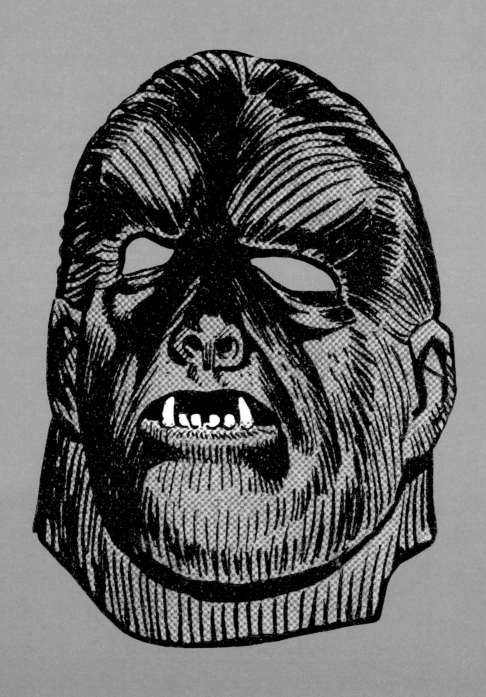

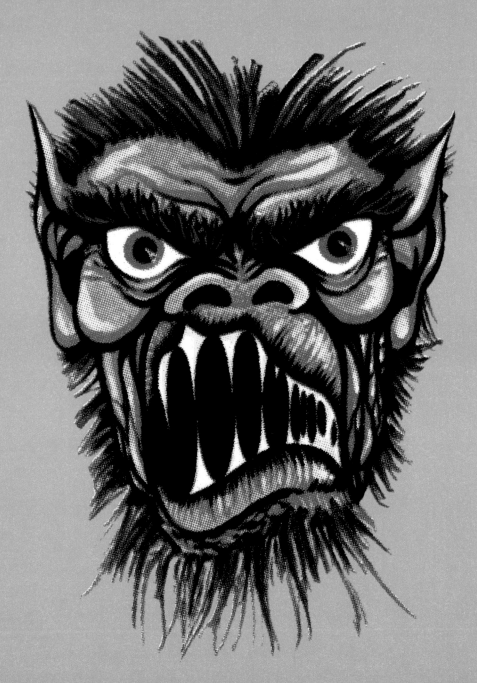

Werewolves are unaware of their own shape-shifting, so it's not only possible that you are a werewolf and don't know, it's probable. Have you noticed that many of your neighbors are

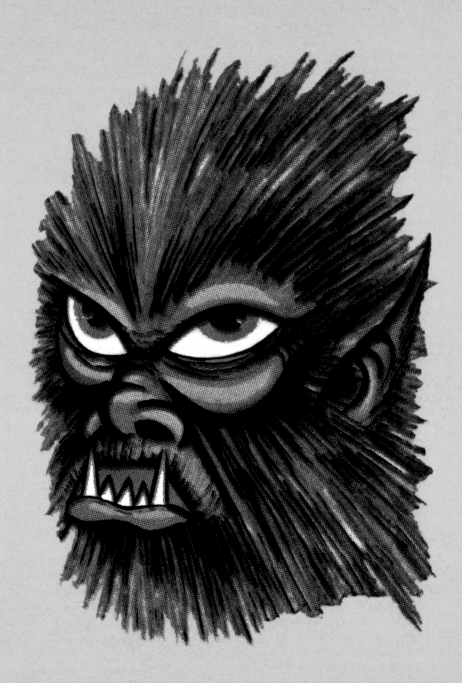

missing? Do you sometimes wake up with bits of pants in your teeth? Are your couches and carpets mysteriously stained, yet you don't own a pet? My friend, you are a werewolf.

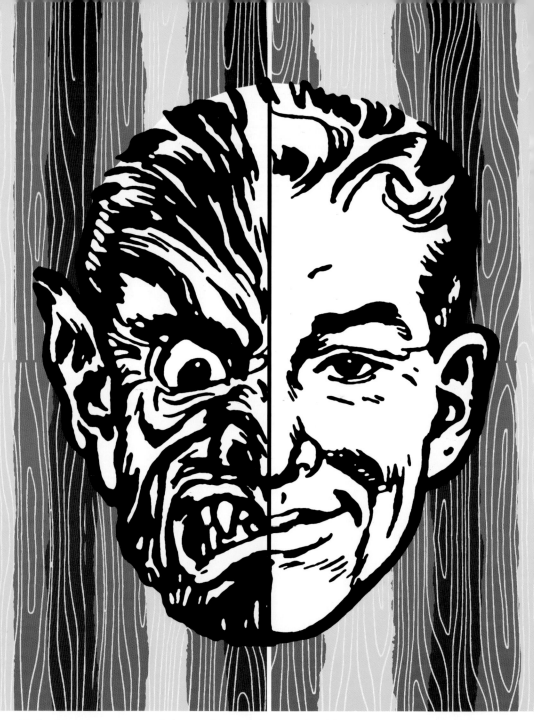

It's healthy every now and then to let your inner animal loose and let him howl. Have an extra scoop of low-fat frozen yogurt (no toppings), say the word "crap" in front of your in-laws, or go several miles an hour over the posted speed limit. *Hoooowwwll!*

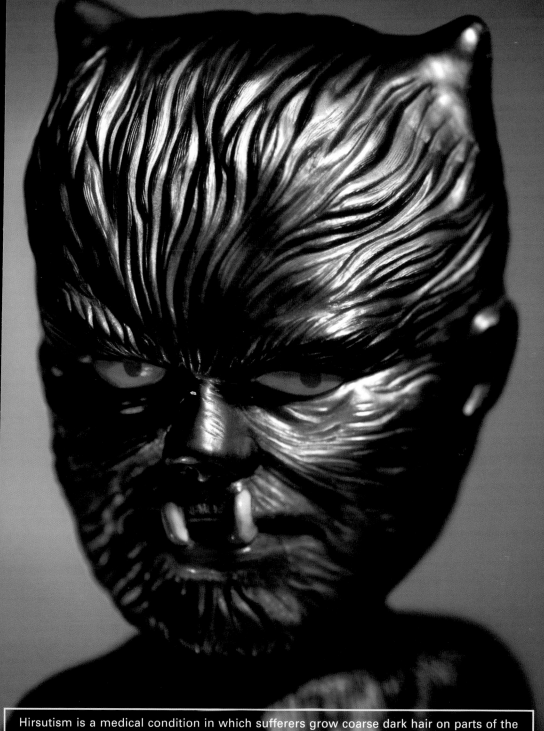

Hirsutism is a medical condition in which sufferers grow coarse dark hair on parts of the body where hair does not normally grow. How do you know if you have hirsutism? If you have to shave your eyelids, the inside of your ears, or your lips, you probably have it.

MUMMY

Ancient Egyptians believed that the body had to be intact in order for the dead to pass into the afterlife. So they took the corpse, sliced 'er open, yanked out the organs, and crammed 'em into jars; hacked the brain up and drained i' through the nose; packed the body in salt for a couple months until it was nice and dry; then crammed sawdust into the chest cavity, stitched 'er up good, and Bob's your uncle, it was a mummy! Into the afterlife it went, kind of like a glorified hunk of beef jerky.

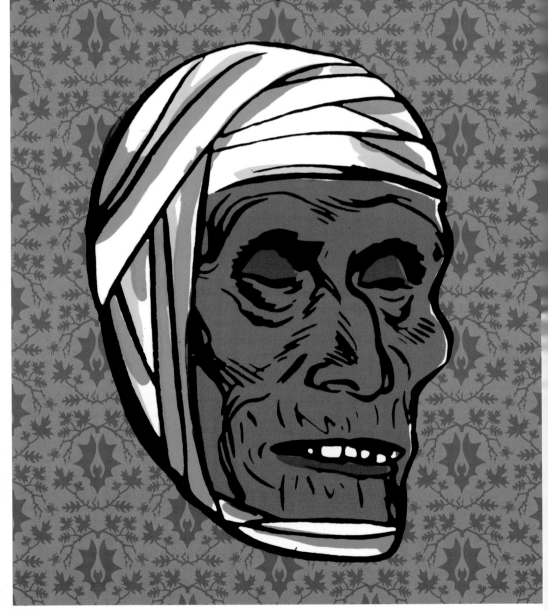

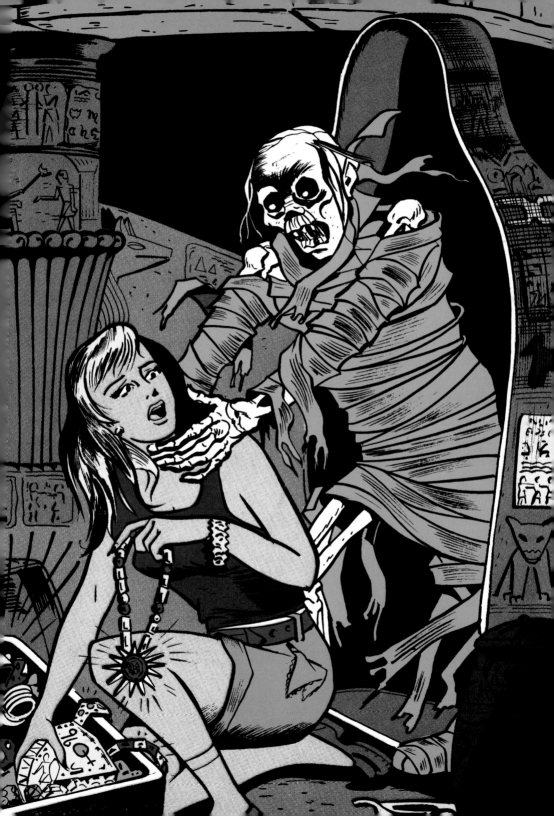

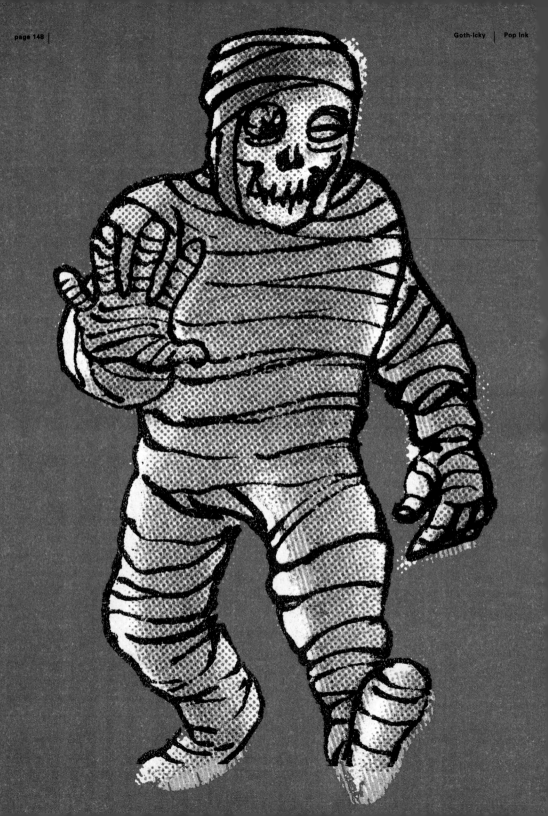

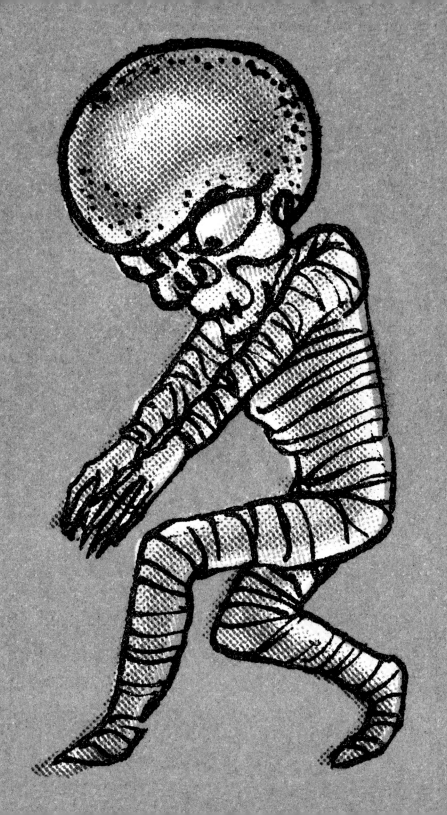

Just because mummies are dead, doesn't mean they can't pull off some fabulous Bob Fosse dance moves. This guy's just managed a Shorty George, kick-ball-change, into a Tacky Annie, and will finish with a Shim-Sham—if he doesn't crumble apart first.

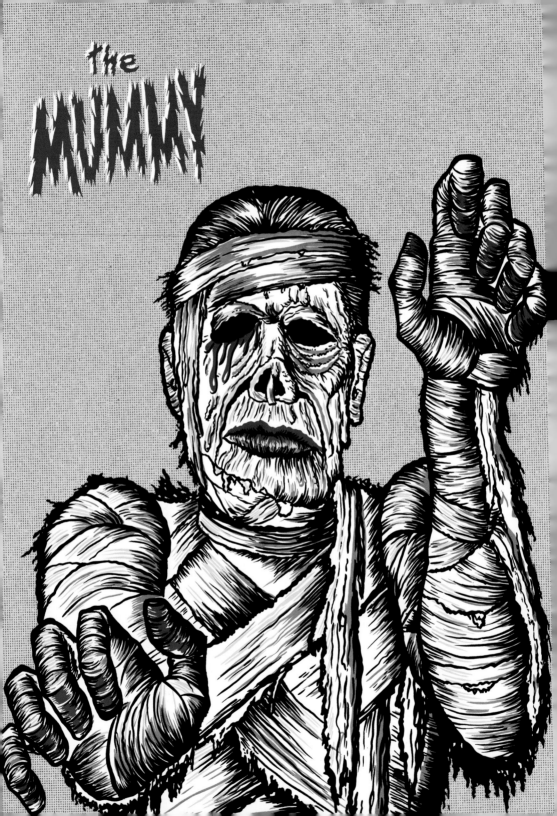

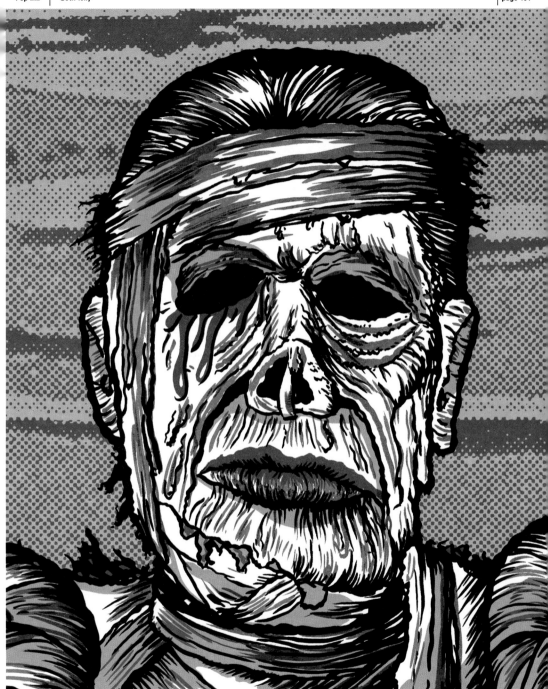

This is, quite frankly, a poorly prepared mummy. The incompetent priests slipped while sucking the brains out, and sliced off his nose. And they didn't leave him in the salt long enough; as you can see he's leaking fluids. And the lipstick job–he looks like Carol Channing. Very shoddy work.

MONSTERS

Though it may seem a little dismissive, a "monster" is any hideous creature that doesn't fit neatly into any of the other more specific categories. It may be that he's a one-time creation who never really caught fire with the public. An example, below, is Goatfish Man, a horrifying amphibian creature who mutilates shepherds before returning to his spawning grounds. Opposite page, top right, is Shingle Face; bottom right is Wombat Man, the killer marsupial; and top left is Beehive Head Cyclops Man (he died in a fall before ever killing or even frightening anyone).

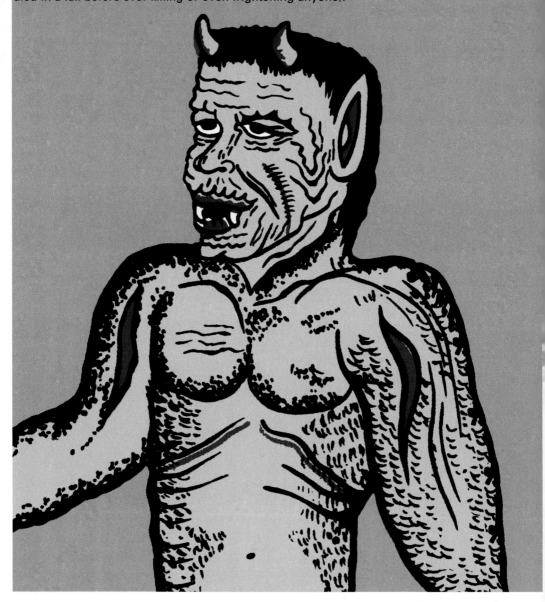

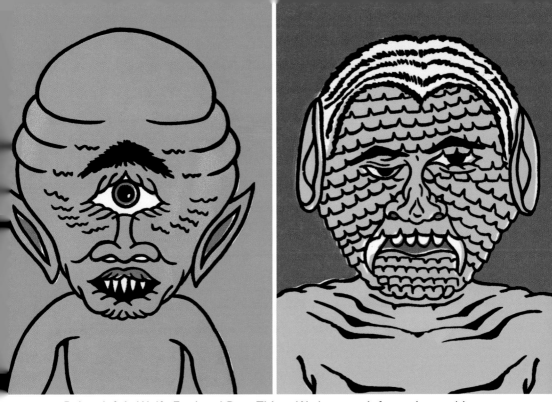

Below left is Wolfy Egghead Bear Thing. We have no information on him.

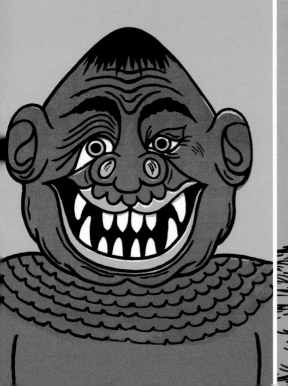

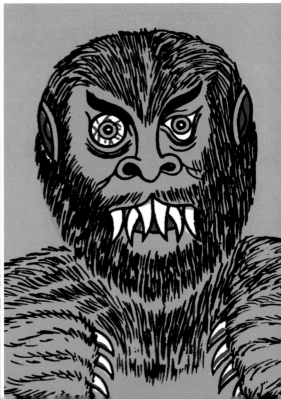

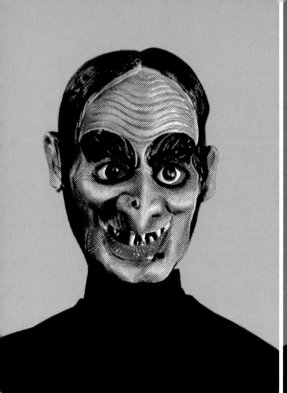
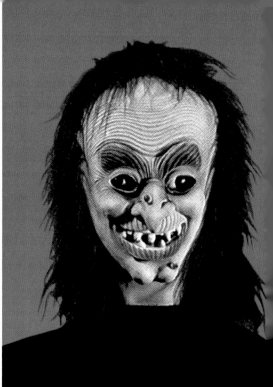

One fun thing to do is to put a mask on and then just stand there.

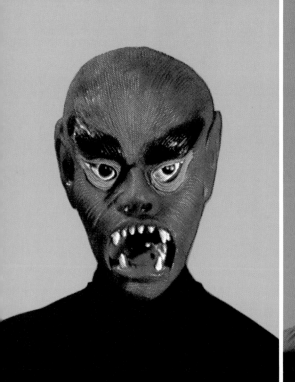
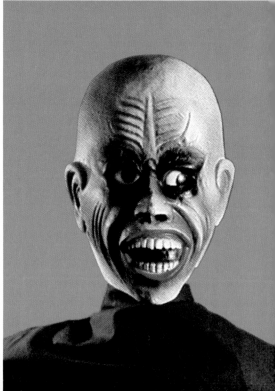

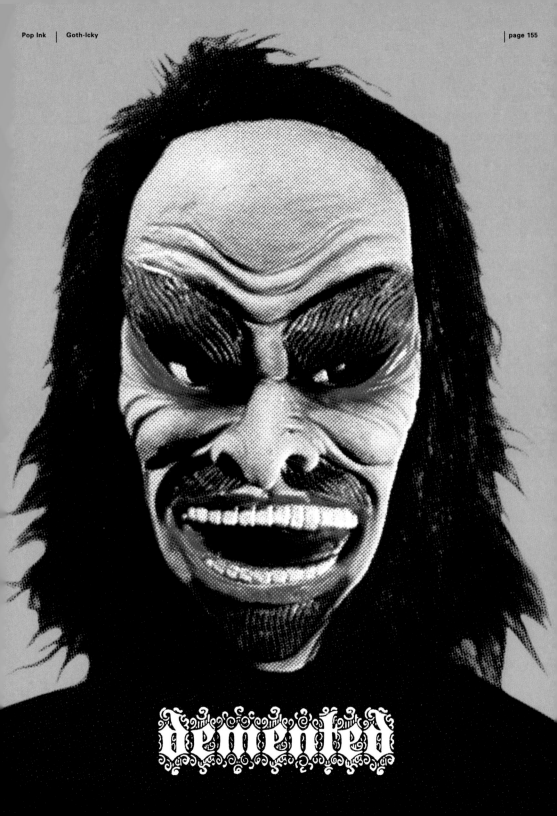

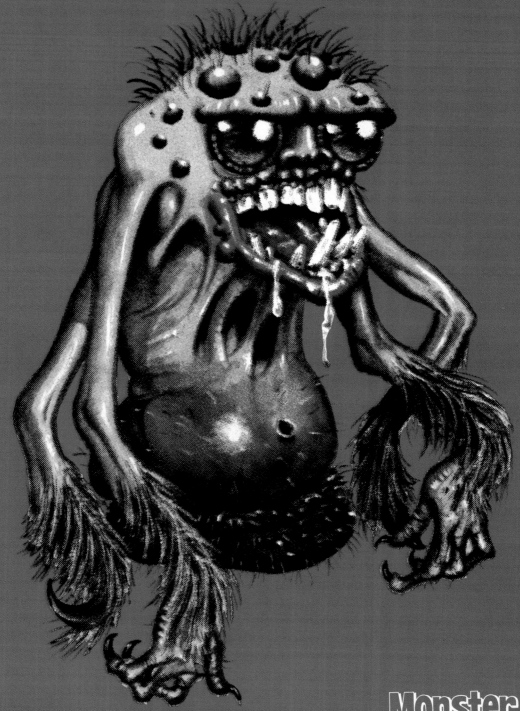

Monster

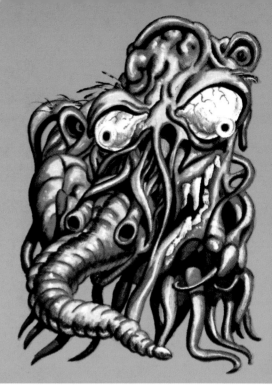

These beasts are related to the creatures that live in our eyelashes, hanging out while waiting for our dead skin to flake off. Luckily, we flake off a lot of dead skin and they rarely go hungry.

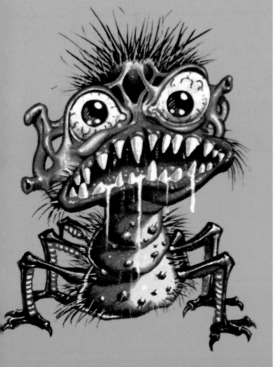

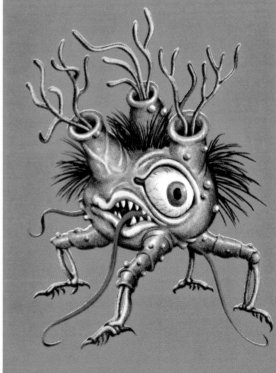

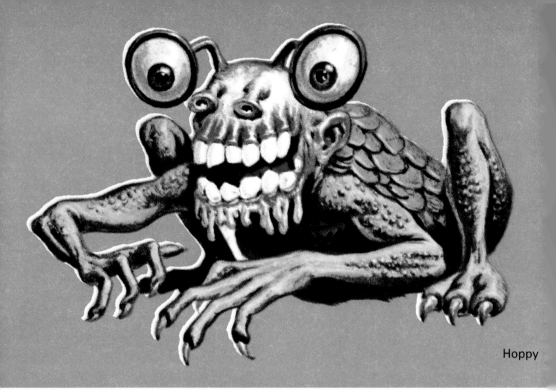

Hoppy

Surprisingly, neither of these guys has particularly good vision. Both wear contacts.

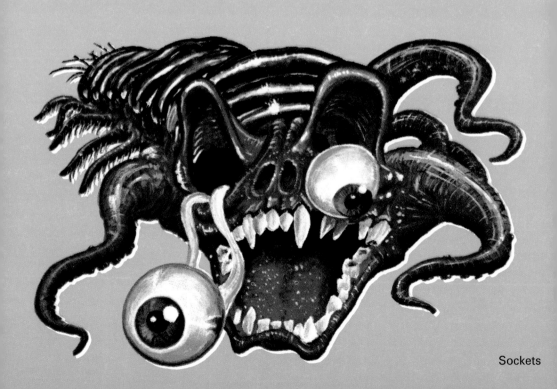

Sockets

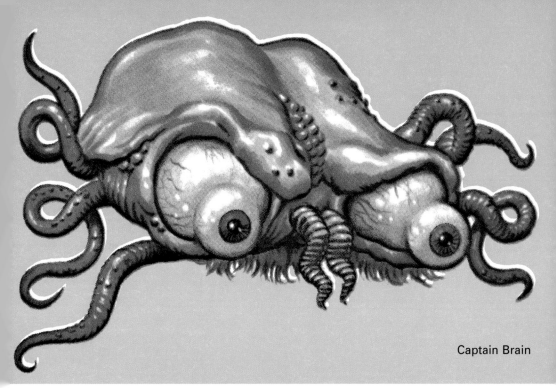

Captain Brain

Beyond being powerfully ugly, these two have extremely limited monster abilities.

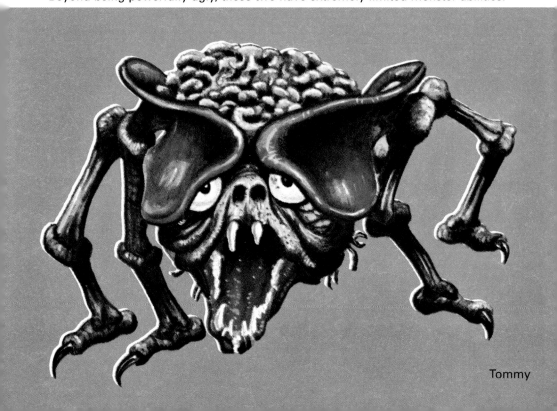

Tommy

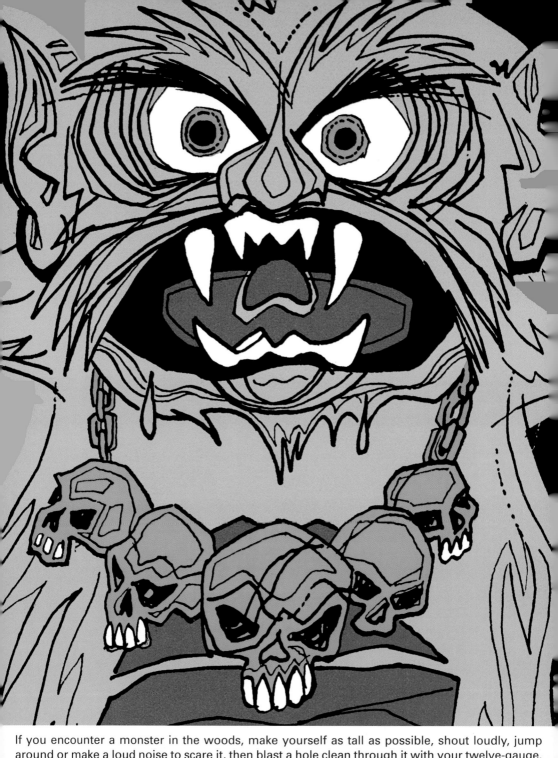

If you encounter a monster in the woods, make yourself as tall as possible, shout loudly, jump around or make a loud noise to scare it, then blast a hole clean through it with your twelve-gauge.

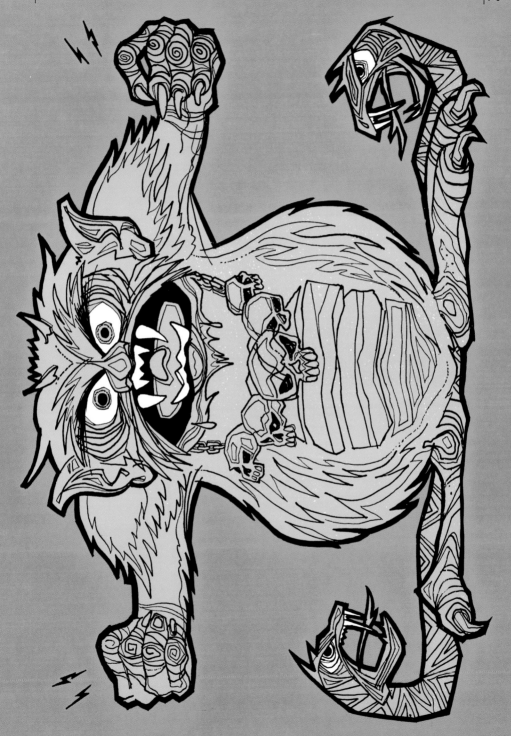

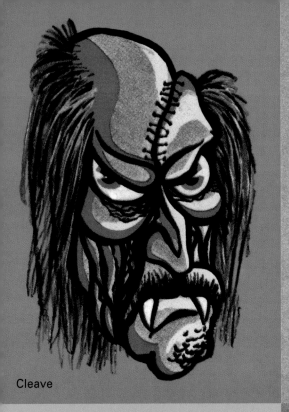

Cleave

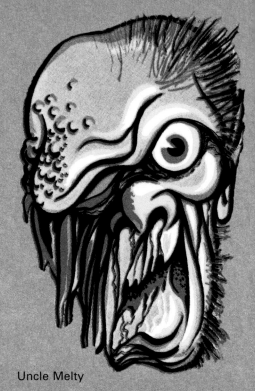

Uncle Melty

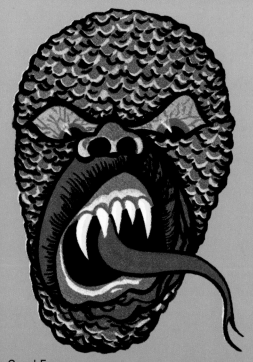

Coral Face

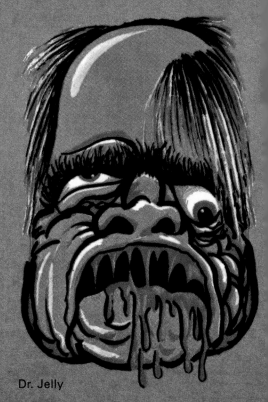

Dr. Jelly

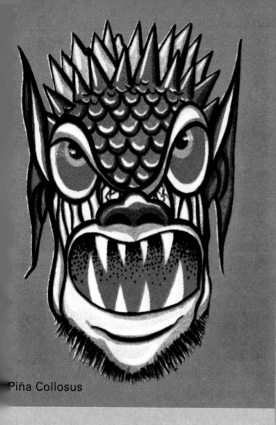

Piña Collosus

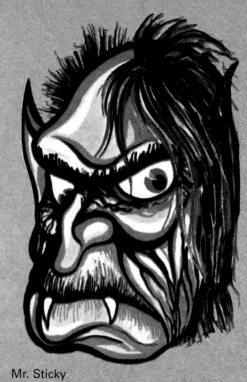

Mr. Sticky

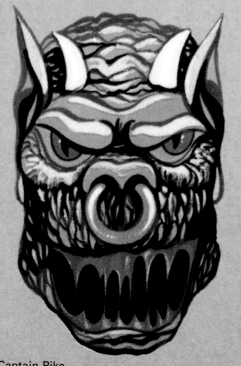

Captain Pike

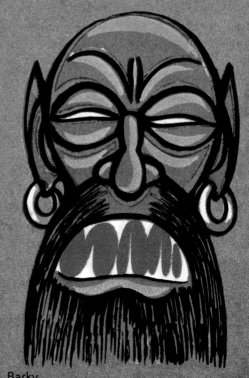

Barky

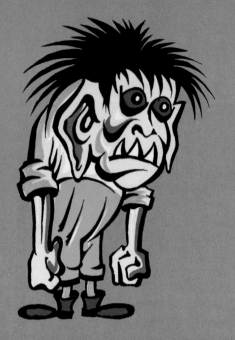

High-Trouser Ed

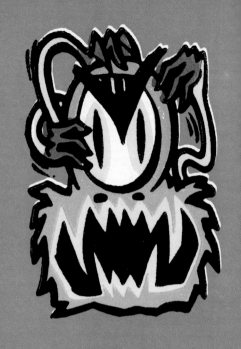

Handy

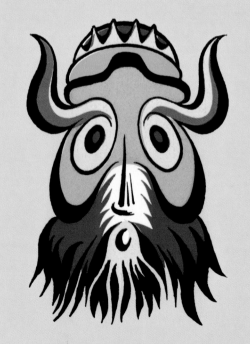

Goat Boy

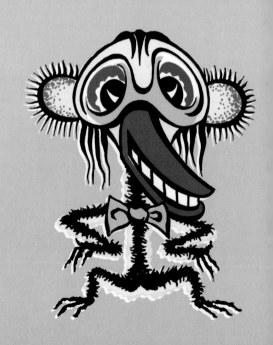

Quackers

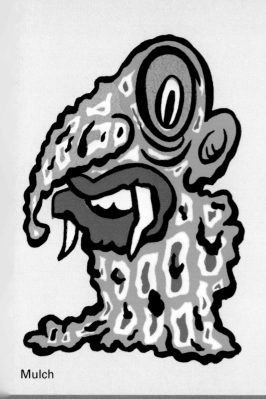

Mulch

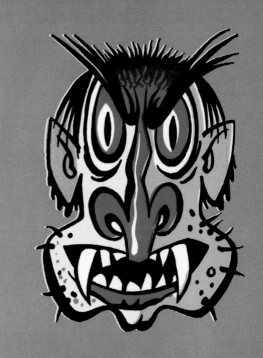

Angry Bob

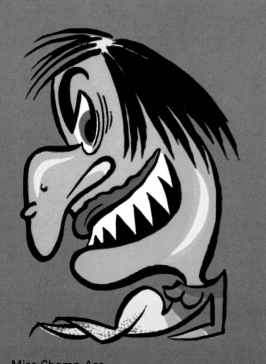

Miss Chomp-Ass

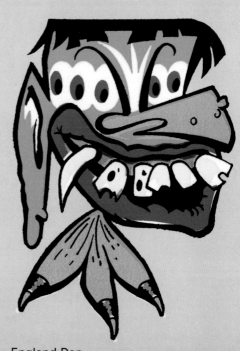

England Dan

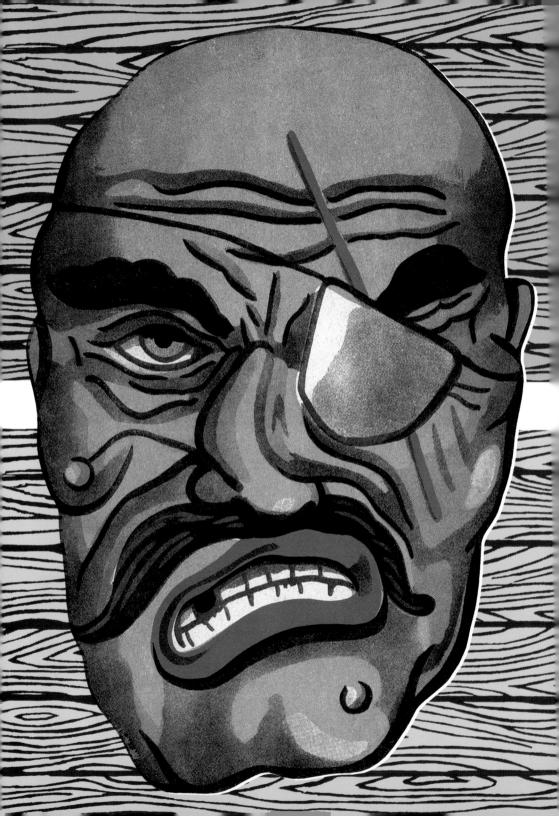

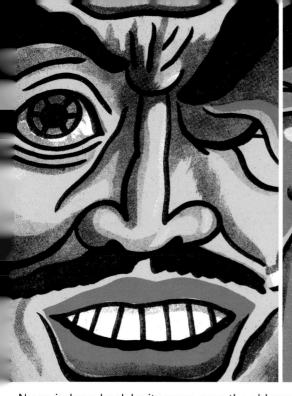

Never judge a book by its cover, says the old expression. Go right ahead and judge these guys, though, and I'm guessing you won't go too wrong. (Hint: Guess "homicidal killer" and you're fine.)

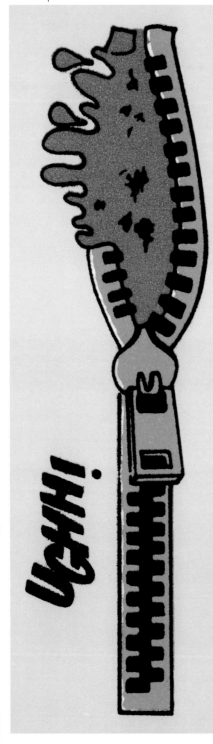

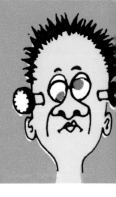

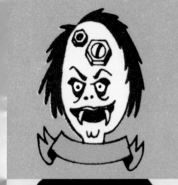

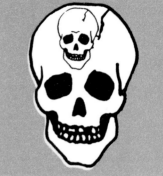
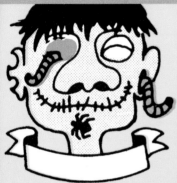
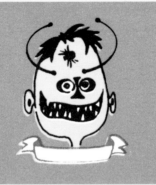
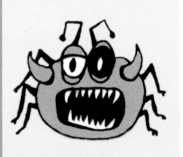

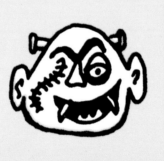

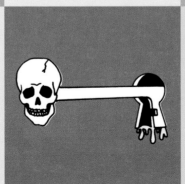
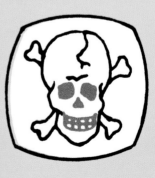

DEMONS

He is known as Satan, Old Scratch, the Author of All Lies, Old Bendy, Devil, El Diablo, Lucifer, Beelzebub, the Tempter, the Wicked One, the Arch Fiend, Belial, Prince of Darkness, Evil One, Semihazah, God of this World, Pan, Azazel, Serpent, Mephistopheles, Adversary, the Dickens, Man-Goat, Angel of the Deep, Old Gooseberry, Monarch of Hell, Old Cloots, Abaddon, Black Donald, Ebru Labadon, and the Prince of Pain. But his real name is Phil Johnson and he lives in Coon Rapids, Minnesota, where he manages a dry cleaning store and does a little deviling on the side.

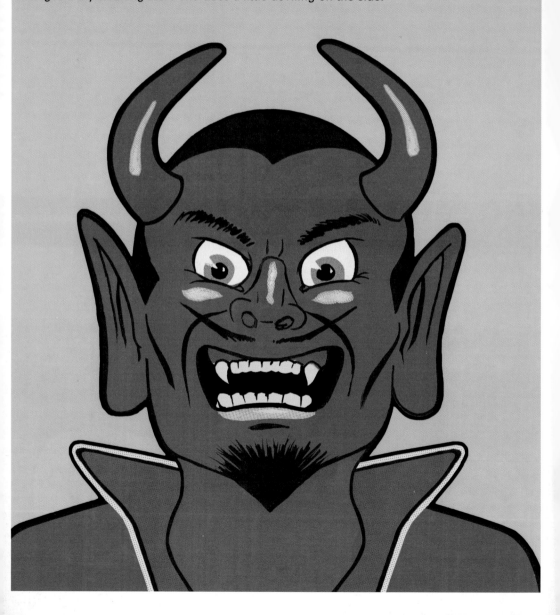

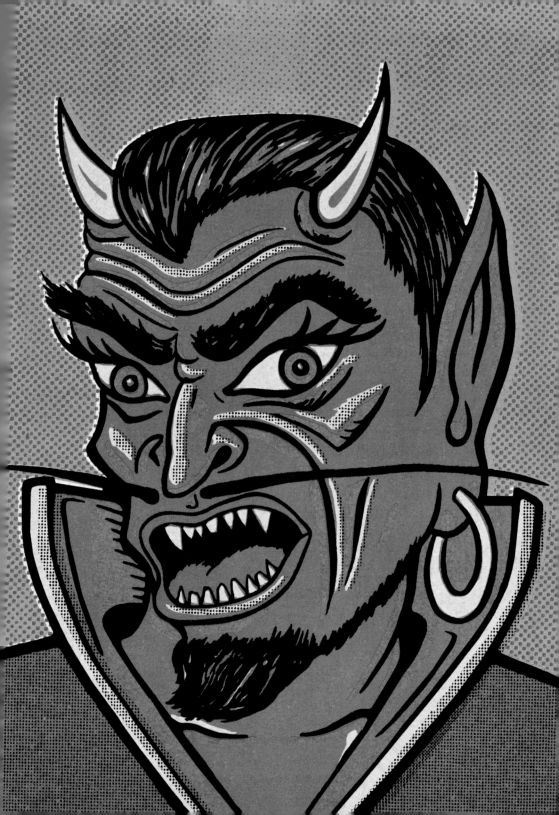

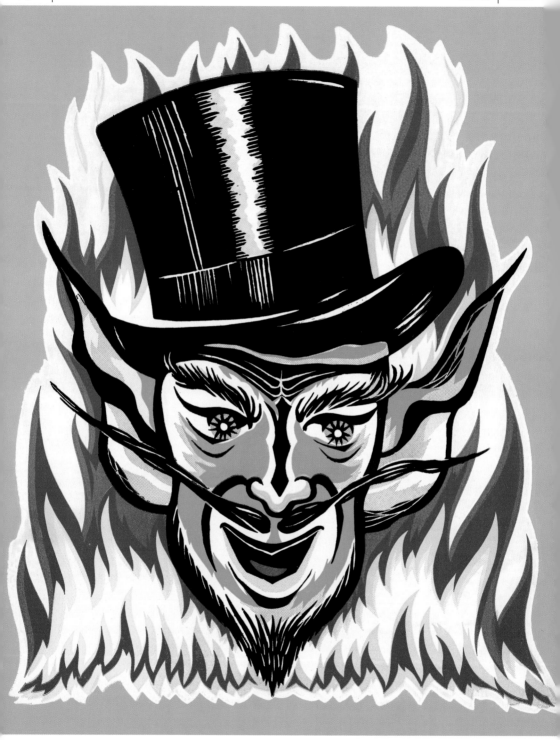

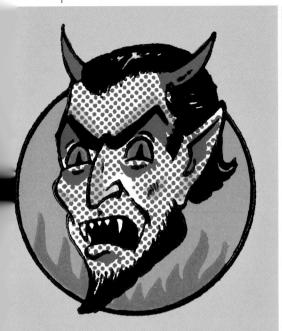 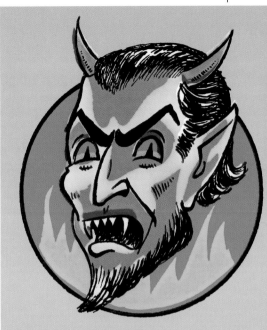

Devils were never depicted with horns until late in the 1800s, when the devil's stupid cousin, Bob, married a goat. They had six horned children (not the brightest kids you've ever met).

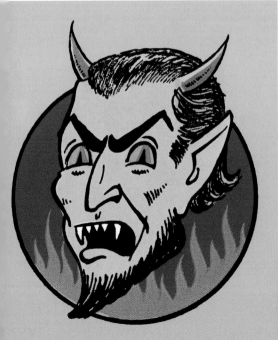 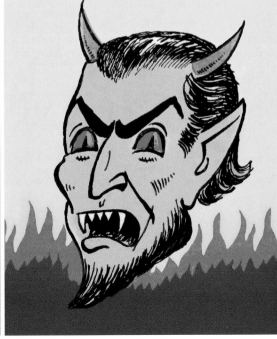

Most demons work through temptation or fear. Not Steven. He's an approachable demon with a smile on his face, a joke for everyone, and an open door policy. "You catch more flies with honey than with vinegar," says Steven. Steven's been named Hellion of the Month more than any other demon.

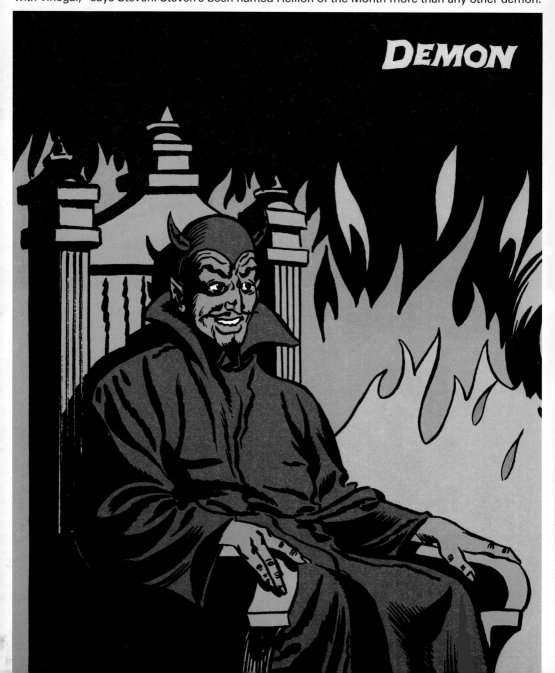

DEMON

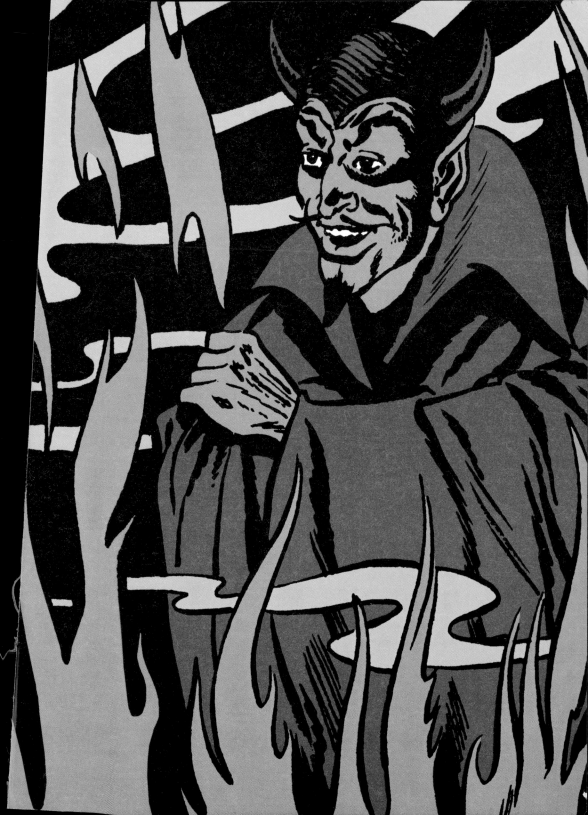

Charles Spencer Anderson is a designer and pop culture junkie.

Pop Ink is the result of over 15 years' worth of work by the Charles S. Anderson Design Company (est. 1989), and a lifetime's work by its founder. Fighting to humanize slick, impersonal corporate design, Anderson popularized the use of hand drawn art, uncoated paper, and irreverent humor through work for long-time client and friend Jerry French of the French Paper Company. Charles S. Anderson Design Company's approach to design is a continuous evolution inspired by the highs and lows of art and popular culture. CSA Design has worked with companies as diverse as Barneys, Urban Outfitters, Coca-Cola, Target, Best Buy, Turner Classic Movies, Nike, Blue Q, Levi's, Ralph Lauren, and Paramount Pictures. The firm's innovative identity, product, and package design has won nearly every industry award possible. Anderson has three sons, Matt, Blake, and Sam, and lives in Minneapolis with his wife, designer Laurie DeMartino, and their daughter Grace Annabella.

Charles S. Anderson Design Company's work has been influential in the industry both nationally and internationally and has been exhibited in museums worldwide including: The Museum of Modern Art, New York; The Nouveau Salon des Cent-Centre Pompidou, Paris; The Smithsonian Institution's Cooper-Hewitt National Design Museum, New York; and The Institute of Contemporary Arts, London.

Built in 1884, this renovated historic building, located in Minneapolis's warehouse district, is home of the Charles S. Anderson Design Company.

124 North First Street
Minneapolis MN, 55401

Karen Heineck

Erik Johnson

Charles S. Anderson

Sheraton Green

Jovaney Hollingsworth

Haley Drab

Each member of the CSA team brings an individual aesthetic that continues to evolve our design approach.

Writer / Actor Michael J. Nelson served as head writer for ten seasons and on-air host for five seasons for the legendary television series *Mystery Science Theater 3000*. He is the author of *Mike Nelson's Movie Megacheese*, *Mind Over Matters*, and the novel *Death Rat*.

VISIT THESE SITES **WWW.POPINK.COM** **WWW.CSADESIGN.COM** **WWW.CSAIMAGES.COM**

Published in 2005 by Harry N. Abrams, Inc.
100 Fifth Avenue, New York, NY 10011
www.abramsbooks.com
a subsidiary of La Martinière Groupe

Design by Charles S. Anderson Design Company
CSA Design, 124 North First Street, Minneapolis, Minnesota 55401
www.csadesign.com

Images by Pop Ink
www.popink.com

K Y M C K Y M C K Y M C K Y M C

Library of Congress Cataloging-in-Publication Data

Nelson, Michael J.
Goth-Icky: a macabre menagerie of morbid monstrosities / Charles S. Anderson Design Company; text by Michael J. Nelson.
p. cm.
ISBN 0-8109-5789-2
1. Grotesque in art. 2. Goth culture (Subculture)— Miscellanea. I. Charles S. Anderson Design Company. II. Title.

NE962.G7N45 2005
760'.0446—dc22
2005004425

Printed in China